Discovering South Carolina's Rock Art

DISCOVERING

South Carolina's Rock Art

Tommy Charles

The University of South Carolina Press

Published by the University of South Carolina Press
Columbia, South Carolina 29208

www.sc.edu/uscpress

Manufactured in the United States of America

19 18 17 16 15 14 13 12 11 10 10 9 8 7 6 5 4 3 2 1

Library of Congress Cataloging-in-Publication Data

Charles, Tommy.
 Discovering South Carolina's rock art / Tommy Charles.
 p. cm.
 Includes bibliographical references and index.
 ISBN 978-1-57003-921-8 (cloth : alk. paper)
 1. Rock paintings—South Carolina. 2. Petroglyphs—South Carolina.
 3. Indians of North America—South Carolina—Antiquities. 4. South
 Carolina—Antiquities. I. Title.
 E78.S6C43 2010
 975.7'01—dc22 2010008306

This book is dedicated to the citizens of South Carolina who have given generously of their time, effort, and economic and moral support toward the ongoing search to discover and learn about, and from, our state's hidden cultural treasures.

Contents

Illustrations

Figures

Unless otherwise stated in the caption, all photographs are by the author.

Preface

Unofficially and unintentionally the South Carolina Rock Art Survey began in 1983, when a collector of Indian artifacts reported a petroglyph located in the Blue Ridge Mountains of Oconee County, South Carolina. Prior to this exciting discovery, it was generally believed that prehistoric rock art did not exist in the state. During the ensuing fourteen years, five more petroglyphs were reported. Although it was meager, this evidence suggested that rock art in South Carolina might be rare simply because we had never searched for it. Toward determining if this premise might be true, I met with a group of Greenville County citizens who had funded other archaeological endeavors and proposed to them that we conduct a survey to look for additional examples of rock art. They enthusiastically agreed to support the project.

The Survey

In January of 1997, the South Carolina Institute of Archaeology and Anthropology (SCIAA) at the University of South Carolina joined with these Greenville County citizens and a host of volunteers to conduct a formal survey to seek and record the state's rock art.

Because of the state's natural geography, we confined our search to the Piedmont and Blue Ridge Mountain regions (see figs. 1, 4, 5, 7, and 8), the areas where most South Carolina rock formations are found. Recording all the various forms of rock alteration was not an objective. Rather we chose to concentrate on petroglyphs and pictographs considered to be products of prehistoric peoples and on historic carvings believed to be of some antiquity or particular interest. Because there were no preexisting studies of South Carolina rock art and because none of the original participants had previous experience in the field of rock-art research, our objectives were modest: to begin the survey, to acquire on-the-job experience, and to see where the research would eventually lead. Initially we inspected public lands and tracts of land owned by our supporters. Early in the survey, however, our failure to find any rock art prompted us to expand our methods to include a media appeal for information from the general public. The immediate success of this approach reinvigorated survey participants and perhaps prevented an early termination of the program. During the following nine years, as time and funding permitted, the rock-art survey continued. Volunteers came and went, each adding new enthusiasm and energy to the cause. As a group, we learned how to search for and record rock art

so illusive as to be almost invisible. In the beginning we would have been elated to know that we would record a dozen petroglyphs, but we eventually discovered sixty-one petroglyph sites (some containing many glyphs) and three pictograph sites. Eight other petroglyph sites that had been destroyed by various means were also documented. Many portable petroglyphs were also documented, but only four were given site designations because all the others had been removed from their original locations.

While this book is not an all-inclusive catalog, the rock art presented in it is representative of the wide variety of motifs we discovered and the landforms on which we found them. To protect the petroglyphs and to honor the wishes of landowners, descriptions of rock-art locations are limited to the counties in which they were discovered.

Methodology

When we began the South Carolina Rock Art Survey, we had little concept of what we would encounter. A search for rock-art information produced an abundance of data about rock art of the American West but relatively little relating to that of the midwestern and northeastern states. There was an even greater paucity of data pertaining to rock art in the southeastern states. Our research reinforced what we already suspected: that the western states hosted a far greater number of known rock-art sites than those states east of the Mississippi River and that rock art of the West is generally in a much better state of preservation. It was also clear, however, that many examples of well-preserved rock art do exist in the East, and we hoped that highly visible rock art might also be found in South Carolina. Ultimately we discovered such glyphs, but with the exception of some historic examples, most were located near mountaintops. Thus, because we began the survey on much lower elevations where the conditions for survey, both physical and visual, are vastly different, our hopes were at first largely unfounded.

On our initial ventures into the field in the upper Piedmont and mountain foothills, we encountered large numbers of rocks covered with forest debris and no petroglyphs. Only later did we discover petroglyphs, which became faintly visible under conditions created by a rainy day, on these landscapes. The lesson we learned was that dark, rainy days created optimum conditions for finding elusive glyphs, and such days became favorite times for survey. Later another chance discovery was a portion of a petroglyph peeking from beneath a deposit of forest debris (plate 6a). As a result, we decide to clean rocks that otherwise could not be examined for petroglyphs. The wisdom of doing so was supported by our discovery and recording of a number of glyphs. Most of these petroglyphs were eroded beyond obvious visibility. We found few petroglyphs considered to be prehistoric that were clearly visible in the light of day until we expanded our search to the mountain crests.

In order to find and record South Carolina rock art in the Piedmont, not only did we have to remove accumulations of forest debris, but in many cases we also had

to use soft watercolor brushes and a weak solution of talc powder and water to trace some petroglyphs for better visibility. Until very recently such procedures were common and even considered necessary to view and record some rock art. More recently, however, some researchers have called for no alteration or physical enhancement of any rock art. This philosophy is well intended and decidedly appropriate for much of the world's rock art, but it is more appropriate for areas such as the American West, where the climate has been kinder to rock art than it has been in humid South Carolina. South Carolina rock art does not share the physical presence of western rock art, its ability to withstand the ravages of nature, or its potential for long-term, or even short-term, human-assisted protection. Given these inequities, the idea that a common search and recording methodology is applicable for all rock art in all areas seems unfounded.

If we had adhered to currently popular methods, much of our state's rock art would have remained undiscovered and unrecorded. Our choices were few and clear. We cleaned rocks to inspect them for hidden rock art; we enhanced all grooves that might possibly be petroglyphs to determine if they are indeed cultural; and we defined and recorded the rock art we found to the best of our ability. Had we not used such methods, it is likely that natural forces or economic development would have destroyed many examples of rock art without their existence ever being known. Our methods were the reason our survey was successful. Given the natural deterioration and human destruction of rock art, it is reasonable to do what is necessary to obtain all the data possible while the opportunity exists.

Acknowledgments

It is impossible to thank all the many individuals and the various news media that assisted the South Carolina Rock Art Survey. Many supporters have given generously of their time, labor, encouragement, cooperation, money, and media coverage. Without them the survey would not have been possible or successful. I cannot adequately express how much I appreciate their many contributions.

The economic and moral support of Greenville County citizens Scott and Lezlie Barker, Sharon Blackwell, Anthony Harper, and John and Patty Walker—as well as Johns Island resident Elizabeth Stringfellow—made it possible for the South Carolina Rock Art Survey to come to fruition. Dr. Brian Siegel, a professor at Furman University, also assisted in the formative stage by volunteering and enlisting some of his students for field surveys. Vivian Hembree and Jack Waters were among the first, and most faithful, volunteers; when the survey was first begun and successes were few, they stuck with it day after discouraging day. The W. C. Bramlett family was unfailing in its support, especially Mike and Allan, who logged many miles of survey and were instrumental in discovery of several important sites. Wes Cooler and Dennis and Jane Chastain shared their considerable knowledge of the mountains of Pickens County and were determined in their efforts to ferret out petroglyph sites by personally surveying and by soliciting information from their friends and neighbors. Dennis was instrumental in getting us into places in the mountains where we otherwise could never have gone. All the sites located near mountain crests were recorded because of his knowledge of the area. Lezlie Barker and her son, John, assisted with on-site photography and spent many hours scanning and copying to CDs the many slides and other photographs acquired during the survey. Jeff Catlin, Alan Coleman, Eugene Crediford, Brian Johnson, Richard C. Otter, and Wes Walker assisted with various aspects of photography. Eddie C. Reeps contributed his time and surveying talents to map several of our most important sites.

I wish to thank University of South Carolina Media Relations for dispersing our plea for assistance to newspapers across the Piedmont and Blue Ridge Mountain regions. Their request drew immediate and positive response from our state's citizens and energized a floundering survey. It also triggered continuing news coverage over the course of the survey, which was instrumental in the recording of sites that we otherwise would not have discovered. Coverage of the survey appeared in the *Charlotte Observer*, the *Easley Progress*, the *Greenville News*, the *Keowee Courier*, the *Laurens County*

Advertiser, the *Seneca Daily Journal,* the *Spartanburg Herald,* and the *Ninety Six Star & Beacon.* Equally rewarding was television coverage provided by Glenn Gardner of Video Production / South Carolina Wildlife TV, South Carolina Department of Natural Resources (SCDNR), as well as the Educational Television Network of South Carolina and their stations WRET-TV of Spartanburg and WYFF-TV of Spartanburg-Greenville.

Several people at the SCDNR contributed to the success of the survey. Sam Stokes, regional wildlife biologist and manager of the Jocassee Gorges property, was instrumental in allowing our access to certain areas of interest. Corporal Malcolm M. Erwin III assisted with survey of the Lake Jocassee shoreline area, and Chris Judge, archaeologist for SCDNR, assisted with the survey of certain Heritage Trust lands. The SCDNR also published Dennis Chastain's article about the South Carolina Rock Art Survey in *South Carolina Wildlife Magazine* (November–December 1999), which proved beneficial to our cause. The assistance of SCDNR personnel and Dennis Chastain is deeply appreciated. Thanks are extended to G. Poll Knowland, manager of Table Rock State Park, Chris Hightower, manager of Lake Hartwell State Park, and Mac Copland, manager of Keowee-Toxaway State Park, for permission to survey certain portions of their parks and to archaeologist David Jones and Charlotte Talley of the Department of Parks, Recreation and Tourism for their assistance in the field, and to Max Williams, manager of Chau Ram County Park in Oconee County, Paul Ellis, director of the Department of Parks and Recreation in Greenville, and Pat Veasey, director of education for Historic Brattonsville in York County, for allowing us to survey their parks. Each of the following individuals discovered and recorded a rock-art site: James Bates, archaeologist for Sumter National Forest, U.S. Department of Agriculture Forest Service; Jim Errante, archaeologist and cultural-resources specialist for the National Resource Conservation Service, U.S. Department of Agriculture; Wayne Roberts, archaeologist for the S.C. Highway Department; Paul R. Dulin, project forester for the S.C. Forestry Commission; Andrew Carroll, research associate at the University of Tennessee at Chattanooga; and Dr. Cato Holler Jr., director of the Carolina Cave Survey. Their much-appreciated data are included in this book.

A close relationship developed between our crew and the staff of the Pickens County Museum: Eddie Bolt, Helen Hockwalt, and Director Alan Coleman. The museum supported our efforts in many ways, including the sale of rock-art tee shirts and coffee mugs to raise funds in support of the survey. Susan Turpin, director of the Spartanburg Regional History Museum, made available Stephen Stinson's photograph of the Pardo stone. The South Carolina State Museum allowed access to a petroglyph in their possession. I am grateful to all.

A portion of one site, Hagood Mill in Pickens County (38PN129), required extensive excavation to remove an old road that covered a portion of the site. The Pickens County Museum granted permission to excavate, and Pickens mayor Ted Shehan gave his support, as did Dr. J. H. Jamison of the Pickens County Cultural

Commission. The City of Pickens supplied a backhoe to excavate and a water truck to wash away loose dirt. Further assistance came from June Bowers of the Pickens City Council; Chris Eldredge, Pickens city administrator; Michael Tate, supervisor of the Street and Sanitation Department; Tim Kelley of the Street and Sanitation Department; and city employees Henry Anthony and David Taylor. The Blue Ridge Electric Co-op provided a cherry picker so our photographer could be elevated high enough to capture the entire site in a single photograph. Alan Warner, supervisor for Hagood Mill, provided valuable assistance with many on-site needs. Alan has a talent for making things work. Many volunteers assisted with excavations and mapping of the Hagood Mill petroglyphs, including Lezlie Barker, Eddie Bolt, Mike and Sherry Bramlett, Alan Coleman, and Brian Johnson. Mark Fisher and his staff and students from Cherokee Creek Boys School of Oconee County participated in the excavations. The students had a blast, and we received some very welcome free labor. Brevard College students Genevieve Allison, Leah-Key Manatis, Marydale Oppert, and Susanne Smith assisted with preparing the glyphs for photography and mapping. The cooperation from everyone was more than we could have hoped for, and the good will of the Pickens citizens in general made for an extremely satisfying venture.

Paul Blessing, forest manager at Poe Creek State Forest and Piedmont Nursery Education Center, South Carolina Forestry Commission (Oconee County), supplied all-terrain vehicles for an excursion.

Permission to survey privately held lands was granted by the following individuals: Jim Anthony, Millen Ellis, James Gambrell, Dale Holmes, J. R. Hughes, Mike Jaskwich, Daryl Keese, Erhart Kohl, Tim Lord, Steve and Howard Moore, Carl A. Niemeyer, Bryan R. Norris, Rick Page, Lester Pool, Eugene W. Rochester Jr. and Phyllis Rochester, Pat Rosemond, Herbert W. Stalling, Peggy Swift, Mr. and Mrs. T. J. Timmerman, William and Steve Timmons, John L. and Tallulah Turner, John and Patty Walker, and David Wilkins.

I am indebted to several people for their contributions of information. When searching for data pertaining to the circle-and-line petroglyphs discussed in chapter 4, I was fortunate to learn of Charles D. Hockensmith of the Kentucky Heritage Council. Hockensmith has done extensive research on this particular style of petroglyphs and was kind enough to share his considerable data with me. Dr. Fred E. Coy Jr., coauthor of *Rock Art of Kentucky,* also shared his considerable knowledge and wisdom. Dr. James L. Swauger, curator emeritus of anthropology at the Carnegie Museum of Natural History in Pittsburgh, provided information on the circle-and-line petroglyphs of Ohio and Pennsylvania. Editor Shirley W. Dunn provided an article by Leah Showers Wiltse that mentioned the use of the circle-and-line petroglyph for lye leaching in upstate New York. Dr. Carol Diaz-Granados of Washington University, St. Louis, sent information about two circle-and-line petroglyphs reported in Missouri. Carol A. Hanny supplied information about lye-leaching stones in Connecticut and Massachusetts, and Cody Spendlove contributed data and photographs pertaining to similar petroglyphs in northern Arizona and southern

Utah. Ray Urbaniak provided additional information about these western petroglyphs. Ann Moore, president of the Foxfire Fund, Inc., Mountain City, Georgia, made available several photographs for inclusion in the chapter.

Dr. Johannes H. N. Loubser of New South Associates, visited site 38PN81 while I was in the process of recording it and gave helpful advice and encouragement. Jane Kolber responded to my request for information on recording rock art by sending a copy of her 1998 pamphlet on the subject, written for the Arizona Archaeological Society.

Special thanks are owed to David Wilkins, co-owner of the Rock golf resort in Pickens County and to property-rentals managers Brooks Galloway and Tammy Kent for supplying lodging on so many occasions; their contributions helped immensely with stretching our budget. Thanks also to Jan Chappell, operations manager, who arranged several dinners for our supporters at the Rock clubhouse.

To all those people who spent a day rambling with us, called to report possible petroglyphs, sent monetary contributions, or supplied information: we can never thank you enough for your interest and support. Know that your efforts are remembered and appreciated beyond our capabilities to express.

Those who assisted us include John Abrams, Lee Adams, Ron Ahle, Russell Aiken, Jean Allan, Bobby Almon, Meloney Aranda, Sara Jane Armstrong, Mr. and Mrs. William Arrington, Scott Ashcraft, Denise Bailey, William T. and Reba Ball, Paul Banner, Danny Barksdale, Estill and Donnie Barnett, Tim Barton, Charles Baxley, Coy Bayne, Tom Benko, Gregg Bennett, Tommy Beutell, Charles and Roger Blakely, Olga Bowles, Dennis Bragg, Rick and Eleanor Breazeale, Wesley Breedlove, Terry Brock, Bobby Brown, Jane Brown, Ralph Brown, Steve Brown, Louise Buchanan, L. H. Buff, Mary Strayer Bunch, Earl Burke, R. F. Burns, Russ and Judy Burns, Curtis Burgess, Joe Butterworth, John Caime, Mary Anne Campbell, Jerry Campbell, Cass Capps, Pat Cecil, Lynn Chamblee, Jim Chandler, Allan Charles, Chris Cjapcjak, Earline Clark, Dan Cochran, Ralph Coffman, Brook Connor, Eben Cooper, Casy Cossaint, Wallace Couch, Teacey Cowart, "Bootsie" Cox, Jim Crocker, Wade Cromer, Judy Cromwell, Charles Crowe, Dennis Cunningham, Clover Curry, Martha Curry, Francis Davis, Sam B. Davis, E. W. Deane, John S. Deaton, Don Deer, Dave Demarest, Robert Denny, Leslie Dominick, William Dorris, Nick Dorn, Mel Duncan, Shirley W. Dunn, Jim Duplessis, Anne Eastland, Terry R. Eberl, Dr. Bobby Edmunds, Donnie Edwards, Markley Edwards, Jim Errante, Robby Evatt, Ralph Evens, Terry Ferguson, Charles Fincannon, Tony Fisher, Devin Floyd, Carol Ford, Charles L. Fosers, Wanda Franklin, Maranda Frantz, William Frazier, Darren Free, Tom Freeman, John Frierson, Matthew Fritz, Josh Fuller, Fred Gantt, Gene Gantt, James W. Garren, Blake Garrett Jr., Dianna M. Georgina, Esther and Larry Gerard, Frankie Ginn, Wade Godfrey, Larry Gore, Morris Green, Barry Griffin, Dan and Miriam Hagen, Sylvia Hagwood, Cary Hall, Jim Hall, Steve and Cindy Hamblen, Berne Hannon, Robert Hanselman,

Lori Hansen, Belinda Harding, Russell and Muff Harner, Jim Harrington, Lera Harris, Stephen Harvey, Tim Hembree, Conway Henderson, Len Hendricks, Richard Hewitt, Jim Hill, Kerry Hinkle, Dr. Cato Holler Jr., Scott Hooks, John and Betty Hopkins, Bob Howard, Michael Hudson, Roy Hudson, Tommy Hudson, Patty Huff, Perry Huff, Steve Hyder, Harrison Jackson, Jenny James, Jenny Jannes, John Jenkins, Charles Jeter, Ethelene Dyer Jones, Luke Jones, Deborah-Morse Kahn, Toni Keller, Paul Kelley, Rebecca Kennemur, Alex Kent, Calvin Keys, Clayton Kleckly, Jerry King, Josh King, Margie C. Klein, John Lane, Clyde Laney, Hugh Larew, Bill Larson, Anna Margaret Lawson, Wendell Lee, Willard Lee, Mark Lewis, Mary Liliberte, Roger Lindsay, Bill Lindsey, Kevin Linkenhoker, Jaunita Littlejohn, Rhonda Lockhart, Ed Long, Swain Looney, Tommy Lowe, Bill Lyles, Perry Mack, Clara and Allen MacKenzie, Gail Marcensil, Ford and Martha Mason, Norman Mason, Glenn Massey, Randy Masters, Allen May, Jacky McAbee, Dr. Charles R. McAdams, Dennis McCrady, Carrie McLachlan, Robert McLeod, Mr. and Mrs. Carl M. Miles, Daryl Miller, Dell Miller, Steve Miller, Major William Millwood, Donald Moore, Robert Moore Sr., Robert Moore Jr., Wayne Morgan, William Mosseller, Karl Muller, Phillip Neal, Wayne Neighbors, Tara Noland, Arthur Nowell III, Edwin O'Dell, Bill Owen, Bruce Owens, David and Pam Patterson, William Patterson, Jim Payne, John Perry, Scott Perry, Michael Phillips, Michelle and David Phillips, Burt Pitman, Bob Pitts, Brook Pitts, Charles Powell, Edward Pressley, Linda Price, Erna Prickett, Todd Purkey, Alan Radford, Beverly Renfro, Libby Rhodes, Stacy and Reina Rice, Helen Rich, David Richardson, Steve Richardson, David Riggs, Dennis Robbins, Dot Robertson, Jesse Robertson, Gary Robinson, Janis Rodrequez, William Rodgers, William Roger, Jonathan Rood, Clyde H. Rook, Crystal Ross, Gloria Ross, Mary Julia Royall, Jeannie and Ben Rudisill, William Rutledge, James Ryan, John M. Schmidt, Walter Schrader, Wesley Seaburg, Jeff Sellers, Herman Senter, Joy Sharpe, M. C. Sheriff, Ben Simms, Mrs. Henry Skinner, Eric Smith, George W. Smith, James L. Smith Jr., Kevin Smith, Rick Smith, Robert Smith, William Smith, Thelma Snow, Shannon Spears, Tom Stallworth, Frank and Andee Steen, Van Steen, Kenn Steffy, James Stoddard, Alex Stone, Gary Taylor, Mike Temple, Tom Thompson, Mr. and Mrs. Thomas Timmerman, Rebecca Lynn Tinsley, Mike Tootill, James Townsend, Michael Trotter, Mickel Turner, Jon Ward, Gary Warlick, Janie Watson, Rick Watson, Steve Watts, Ruth Y. Wetmore, John Whatley, Max White, David Whitner, Clark Wickliffe, Roger Wilkie, Mark Williams, Rose Marie Williams, Terry Wilson, Kay Wood, B. H. Workman, Tommy Wyche, Dale Yearwood, and Frank Young.

I especially appreciate the support of my SCIAA Research Division colleagues: Dr. Chester B. DePratter, Dr. Albert C. Goodyear, and Dr. Stanley South. I also thank Dr. DePratter and Dr. Charles R. Cobb for reading and commenting on the manuscript for this book. As always, I am grateful to Dr. Bruce E. Rippeteau, former SCIAA director, interim directors Dr. Jonathan Leader and Dr. Thorne

Compton, and the present director, Dr. Charles R. Cobb, for their unfailing support of this project. Tamara Wilson created several distributional maps for this publication. Her assistance was invaluable and deeply appreciated.

And finally I am forever grateful to my friend of long-standing Antony Harper. Without his encouragement and unfailing support, much of what has been accomplished in terms of archaeological research in the South Carolina upstate would not have been possible.

Introduction

What Is Rock Art?

The term *petroglyph* is derived from the Greek words *petros* (rock) and *glyphe* (carving). It is often used to denote any carving or inscription on rock. *Pictograph,* refers to a pictorial sign or symbol created by drawing or painting without carving on any kind of surface, including rock. Collectively petroglyphs and pictographs are commonly referred to as *rock art,* a popular catch-all term that in its broadest interpretation may include modern graffiti, gravestones, and statues as well as prehistoric works. Human alterations of rock are a result of many intentions, including but not limited to art. Perhaps a better way to describe petroglyphs and pictographs is to call them *rock graphics,* a term used by Carol Diaz-Granados and James R. Duncan in their *Petroglyphs and Pictographs of Missouri* (Diaz-Granados and Duncan, 2000). Nevertheless *rock art* has become the commonly accepted term for petroglyphs and pictographs.

Who Created Rock Art in the New World?

All sorts of theories have been proposed for the origin of North American rock art. Some have proposed that many examples are the work of the Vikings, various Mediterranean peoples, the Chinese, or other Old World peoples who may have migrated to the New World much earlier than we think. That other groups may have found their way to the New World prior to the arrival of the Native American is entirely possible; however, the large number of other peoples needed to produce the many examples of rock art across the continents of North and South America would surely have left a considerable genetic imprint on Native American populations, and such evidence has not been found. The evidence that we now have indicates that the preponderance of North American rock art is the work of Native Americans and, to a lesser extent, more recent immigrants of other races and ethnicities.

Determining the Antiquity of Rock Art

How do we determine if rock art is prehistoric or historic? This is a valid and often-asked question, and we cannot always be certain that we have made the right assessment. Unlike the rock art of the American Southwest, examples found in southeastern North America do not have the patina, or "desert varnish," that is often found on southwestern rocks and sometimes forms over organic materials trapped in petroglyph grooves. From such organic matter, radiocarbon dates may sometimes be obtained. Without such desert varnish, radiocarbon dating of South Carolina petroglyphs has not been an option. Because our pictographs were drawn with nonorganic ocher, radiocarbon dating of them is likewise impossible. Prehistoric cultural materials frequently occur in the vicinity of South Carolina rock art, but almost without exception these materials are multicultural. Because the rock-art motifs are not replicated in any of these artifactual remains, assigning the rock art to any particular cultural period would be arbitrary and indefensible. Although we cannot state with absolute authority that any petroglyph or pictograph is prehistoric, there are clues that suggest placement of rock art in prehistoric or historic categories. If rock art consists of letters of the alphabet, numerals, or other obviously historic representations, then their historic identity is readily established. Claiming that nonfamiliar motifs may be of prehistoric origin is not that clear-cut, but fortunately there are criteria other than the obvious historic identifiers that assist in making judgments. Some of the factors are site location, historic and prehistoric use of the area, the state of erosion of abstract carvings in relation to that of identifiably historic carvings on the same rock, and our perception of the motifs themselves—how rock art envisioned by individuals exposed to current cultures differs from rock art of those peoples nurtured by prehistoric cultures. For example, after their contact with Europeans, Native Americans created many examples of rock art depicting subjects such as guns and people mounted on horse, reflecting their increasing exposure to objects and concepts previously unknown to them. Given the cultural dichotomies of Europeans and Native Americans, who is more likely to have created abstract figures, people of prehistoric or posthistoric cultures? Even today, in some of our western states, there remain large areas where nonaboriginals have not greatly intruded, and in those places arbitrarily assigning a prehistoric origin to abstract rock art might be logical. Unlike the West, however, all South Carolina has long been imprinted by European and African cultures; therefore assigning historic or prehistoric origins to our state's abstract rock art is a subjective decision. Any assessment of the antiquity of a work of South Carolina rock art—and the intent of its creator—is based on how the viewer interprets the glyph and perceives the thought processes of prehistoric and historic carvers and painters. Admittedly this approach is not particularly scientific, but until—and unless—the future brings reliable methods of determining the ages of petroglyphs and nonorganically painted pictographs, perhaps it is the best we can do.

The Meaning of Rock Art

Theories about the meanings of prehistoric rock art abound. In the American West, for example, some were created for religious purposes; others are associated with puberty rites; still others represent rain clouds or clan marks. But many are simply abstract figures having no discernible, or defensible, meanings. Because I do not know the meanings of the abstract motifs found on rocks across the South Carolina landscape, I have focused on recording rock art rather than on trying to interpret it. It is enough to discover, to observe, to contemplate, and to enjoy what has been left behind. The sole purpose of this publication is to share with the public our pleasure and sense of wonder at discovering works of South Carolina rock art by artists long past.

The Survey

Long before a decision was made to conduct a formal search for South Carolina rock art, I had begun a search for information that might assist a better understanding of the few previously reported petroglyphs. A search of the South Carolina Statewide Archaeological Site Inventory, managed by the South Carolina Institute of Archaeology and Anthropology (SCIAA), produced a single record of an earlier-recorded rock art that was unknown to me. In 1979 Dr. Robert L. Stephenson, then state archaeologist and director of SCIAA, filed a brief report describing a single petroglyph at site 38GR9 in Greenville County (figs. 1 and 2). The report consists of little more than a single photograph and site-location data. According to Stephenson, the informant and some local people called the carved stone the "Old Indian Rock," believing that the petroglyph was created by Native Americans. Others thought that the carving might be of Spanish origin. The meandering journeys through South Carolina by the Spaniards Hernando de Soto in 1540 and Juan Pardo in 1566–67 and 1567–68 have spawned folklore that members of these expeditions carved "evidence" of their passing on rocks. Perhaps the best known of these carvings is the "Pardo stone" (fig. 3), a small portable petroglyph that was found in 1934 by Bryson Hammett while plowing on his farm, near the town of Inman, in northwestern Spartanburg County (Jones 1978, 12; Wallace 1936). Now on display at the Spartanburg Regional History Museum, the rock is incised with the date "1567," a parallelogram, and a sun with an arrow pointing away from it. These images have led to speculation that the carved stone was a "direction rock" left by Pardo's expedition. It is unlikely that the true origin of this petroglyph or the date of its creation will ever be substantiated, but it has added to the lore that Spaniards were responsible for creating some South Carolina petroglyphs.

Searching publications about early explorers who ventured into the region produced a much earlier record of a pictograph, reported by James Mooney in 1891. This brief report gives no details about the drawing itself and only vague location data; in its entirety it says: "Pictograph on Table Rock, 4 miles north of Oolenoy River, near Caesars Head Mountain on North Carolina line" (Cyrus 1891, 418–19).

Other than offering hope that pictographs might still exist, Mooney's brief report was of little value; finding a particular pictograph in the area he described would be like looking for the proverbial needle in a haystack. Thus Mooney's discovery could be anywhere within several square miles of rugged mountains in northern Greenville or Pickens counties (fig. 1). Many rock shelters are located in this wilderness, each a potential site for rock art. Because the area is dissected by streams and steep slopes and has few roads or trails, it is difficult to traverse and remains largely unexplored for rock art. Much of Table Rock Mountain and the lowlands on the north side are now within the Greenville County watershed, and this area is off limits to all but a few employees of the Greenville County Water Department. To learn what Mooney had observed and to realize his data were so inadequate that we might never be able to locate the site was both tantalizing and frustrating. Our survey did record a pictograph in this general area but not in Greenville County. The site (38PN102, plate 12), is situated no more than fifty meters over the Pickens County line. Even today the boundary between the two counties is poorly marked in that area, and without the use of a Global Positioning System (GPS)—or the discovery of a modern marker—a trekker is unlikely to be sure of which county he is in. Because Mooney gave no description of the pictograph he visited, however, there is no way of determining if the pictograph we found is the same one observed. Stephenson's and Mooney's reports are apparently the only records pertaining to South Carolina rock art prior to 1983.

Soon after I visited my first petroglyph site in 1983, I began corresponding with Dr. James L. Swauger, one of the stalwarts of rock-art research in eastern North America and curator emeritus of anthropology at the Carnegie Museum of Natural History in Pittsburgh. Swauger maintained a repository for records of eastern-states rock art. After I sent him data from my initial visit to this rock art as well as data pertaining to several other glyphs that were reported over the ensuing years, he graciously sent me a copy of his *Petroglyphs of Ohio* (1984). In 1997, when I inquired about a petroglyph similar to the "peace" symbol that I had recorded in South Carolina, he sent me an article about these particular glyphs, his "Petroglyphs, Tar Burner Rocks, and Lye Leaching Stones" (1981). He also referred me to Charles Hockensmith, staff archaeologist at the Kentucky Heritage Council. Hockensmith had done extensive research on the tar-burner petroglyphs in Kentucky and other eastern states, and he generously shared with me the data he had acquired.

Other publications I consulted were Julian H. Steward's "Petroglyphs of the United States" (1937), Garrick Mallery's *Picture-Writing of the American Indians* (1972), and—for comparative purposes—Robert F. Heizer and Martin A. Baumhoff's *Prehistoric Rock Art of Nevada and Eastern California* (1962). Later we made use of *Rock Art of Kentucky*, by Fred E. Coy Jr. and others (1997), considered the definitive work on the rock art of that state. The only publications we found that related to rock art in reasonable proximity to South Carolina were "Georgia Petroglyphs" (1964) by Margaret

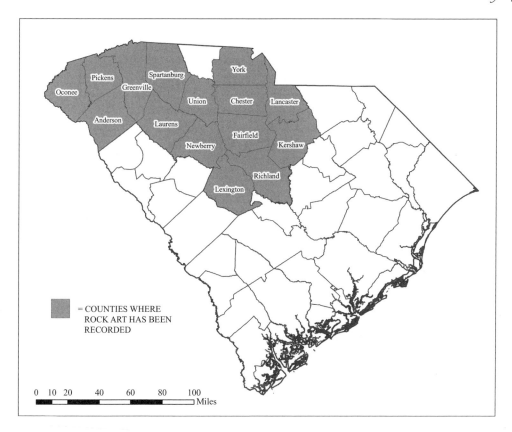

Fig. 1. South Carolina counties in which rock art was recorded

Perryman (the pen name for Francis Smith), and Bart Henson and John Martz's *Alabama's Aboriginal Rock Art* (1979). Several years after our survey had begun, we were able to consult *The Petroglyphs and Pictographs of Missouri* (2000) by Carol Diaz-Granados and James R. Duncan, and *Picture Rocks, American Indian Rock Art in the Northeast Woodlands* (2002) by Edward J. Lenik.

All these publications are interesting and informative; yet none addresses the technical aspects of in-the-field procedures necessary to find previously unknown petroglyphs that are eroded to complete invisibility in natural daylight. Thus these publications were of little use in establishing methods for our survey. Rather they detailed visits to previously discovered rock-art sites where the petroglyphs are at least minimally visible by daylight, and for many of these sites prior photographs and drawings already existed. The greatest contribution of these publications to our survey was helping us to better understand the considerable disparity between the physical preservation of the petroglyphs in other eastern states and that of most petroglyphs we discovered in South Carolina.

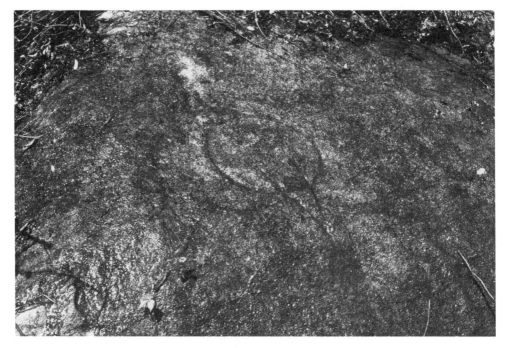

Fig. 2. The first petroglyph site recorded for South Carolina, 38GR9 in Greenville County

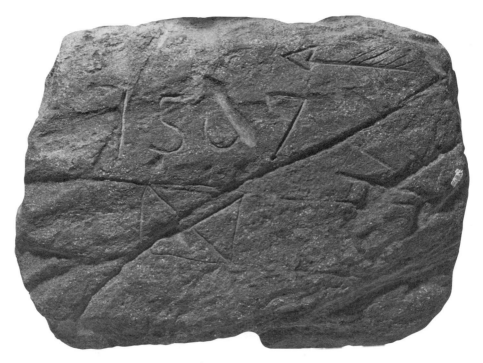

Fig. 3. The Pardo stone. Photograph by Stephen Stinson, courtesy of Spartanburg Regional History Museum

The Area of Survey: A Natural Selection

The Piedmont and Blue Ridge mountain regions of South Carolina are geologically separated from the coastal plain by the fall line, a narrow band of ocean-deposited sand dunes associated with an erosional scarp that extends from New Jersey to Alabama. The fall line is so-called because of the many waterfalls and rapids created by the abrupt drop in elevation that occurs between the Piedmont and the lower elevations of the coastal plain. Distinct from either the Piedmont or coastal plain, the fall line derives its unique geological and botanical character from the xeric sand dunes that were deposited by the ocean during the Miocene epoch between 22.7 and 5.3 million years ago (*South Carolina Naturally* 2001). In South Carolina the fall line divides the state geographically in a southwest to northeast direction (fig. 4), and serves as a natural boundary between the hard Paleozoic metamorphic rocks of the Appalachian Piedmont and the softer, gently dipping Mesozoic and Tertiary sedimentary rocks of the coastal plain (U.S. Geological Survey 2000).

North of the fall line, the land rises abruptly to form the Piedmont, a landscape of rolling hills dissected by numerous streams. The Piedmont extends north-northwest from the fall line for approximately 125 miles to the Blue Ridge Mountains. The Piedmont region accounts for approximately one third of South Carolina's landmass, and it is topologically and geologically vastly different from the coastal plain. South of the fall line, elevations on the coastal plain drop sharply, and the landscape becomes increasingly flat. On the Piedmont and in the mountains, granite, schist, gneiss, diorite, amphibolites, gabbros, and quartz rocks are abundant (Horton and Dicken 2001), thus the potential for rock art occurring in those areas is excellent. As we approach the fall line, these rock formations dip drastically below the earth's surface, so on the coastal plain there is little exposed rock amenable to the creation of petroglyphs. Thus the state's natural landscape dictated the boundaries of the South Carolina Rock Art Survey, and all the rock art we discovered is located north of the fall line (fig. 4) with the majority being found in the counties of Fairfield, Greenville, Laurens, Oconee, Pickens, and Spartanburg (see table 1 and figs. 1, 5, and 8).

The Survey

Our first excursion into the field was in January 1997. A short afternoon outing was preceded by an organizational meeting at the home of John and Patty Walker. I was joined on this initial foray by several citizen-volunteers, a class of anthropology students from nearby Furman University, and their instructor, Dr. Brian Siegel. The only thing that we were sure of was that rock art would be carved or painted on rock. With the excitement of undertaking a much-anticipated venture, we preceded to the upper reaches of the Middle Saluda River in Greenville County. This location has an abundance of large boulders adjacent to the river, and the property was owned by one of our supporters, making it accessible and a great place to practice. We divided

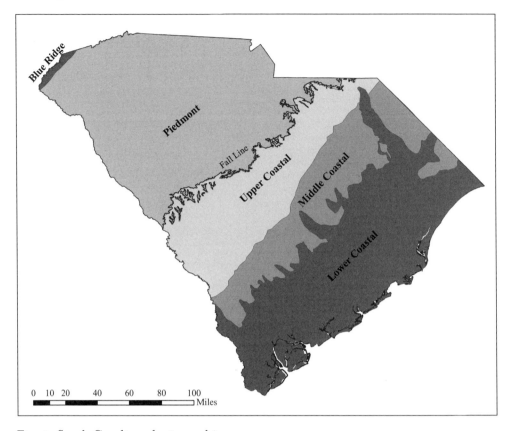

Fig. 4. South Carolina physiographic zones

our group in two so we could simultaneously inspect both sides of the stream. Optimistically we studied rock after rock, the tops of which were most often covered with green moss, lichens, leaves, layers of humus, or combinations thereof. At the end of the day, we had found not the slightest scratch on any rock. For several weeks thereafter, we continually expanded our search area, combing fields and stream banks, investigating near springs, and inspecting just about any rock that we could reach—all the while enduring the same lack of success. Soon most of the volunteers abandoned the survey, and those remaining were becoming skeptical of our chances for success. By early February it was clear that our investment of time and funds were not producing the results we had hoped for. It was time to rethink our methodology. We decided to approach the University of South Carolina Media Relations with a request that they distribute an article about the survey to newspapers across the South Carolina upstate. The article was widely published in February 1997, and shortly thereafter we began receiving reports of "markings on rock."

Our first report was of two portable petroglyphs, one a historic-period circle-and-line (fig. 65) and the other a small, inscribed portable stone considered to be

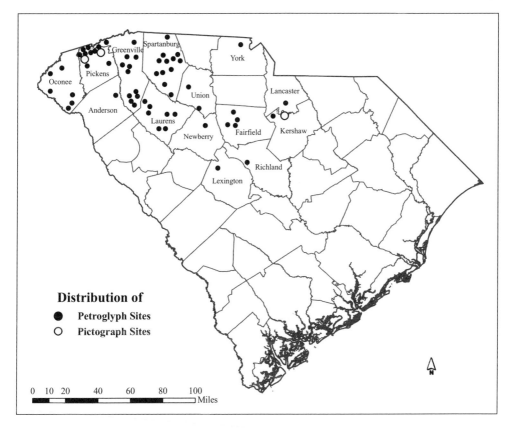

Fig. 5. Locations of South Carolina rock-art sites

prehistoric (fig. 53). Information about other petroglyphs soon followed but they were of historic-period glyphs consisting of names, initials, circle-and-line "tar-burner" rocks, and even an unfinished gristmill stone—each visible to the unaided eye. These reports ultimately lead us too less obvious and previously unknown prehistoric glyphs. It was while investigating the gristmill stone on a rainy day that we inadvertently discovered our first prehistoric rock-art site (site 38PN81).

Encouraged by the public response, we solicited additional information by placing notices in post offices as well as in rural stores frequented by hunters, fisherman, and campers. We instigated more news articles as well as television coverage. We gave lectures at many civic functions, schools, and museums. These activities created awareness, and some brought requests to examine rocks that were thought to host rock art. Our treks took us to many different landforms and into most of the counties located in the northwestern portion of South Carolina. We received no reports of possible rock art from several upstate counties where we thought we might find it, nor did our limited field survey within those counties discover any. This was somewhat surprising, because all the Piedmont and Blue Ridge counties have abundant

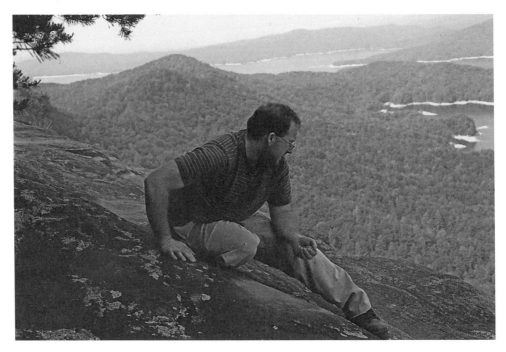

Fig. 6. Michael Bramlett inspecting rock domes for petroglyphs

rock suitable for hosting rock art. Most of our survey was conducted on public property, but we also searched private lands with permission from the owners.

The entire area that we surveyed amounts to a minuscule fraction of 1 percent of the total landmass of the Piedmont and Blue Ridge regions of our state. The fact that we ultimately recorded numerous examples of rock art demonstrates that many other rock-art sites surely await discovery. Because of the difficulty of getting to sites located near mountain crests and the danger of inspecting them at night using lights (a common procedure at the less dangerous lowland sites), exploration of such hard-to-reach areas was limited to the hours of daylight. Reasons for avoiding these precarious heights at night are obvious in figure 6 and plate 3.

Lowland sites, located near the bases of mountains and on the Piedmont, were much safer to survey, and we were able to inspect them by day and night. Rainy days (as we inadvertently learned) were especially good for our surveys because, when rock is wet and under subdued light, it is sometimes possible to see glyphs that are invisible in full daylight (see plate 1). We also used mirrors to reflect sunlight across rocks, creating shadows in petroglyph grooves so we could see them. However, because so many of the sites are located in deeply shaded areas and because the glyphs on lowland sites are so eroded, using mirrors proved much less efficient than inspecting rocks on a rainy day.

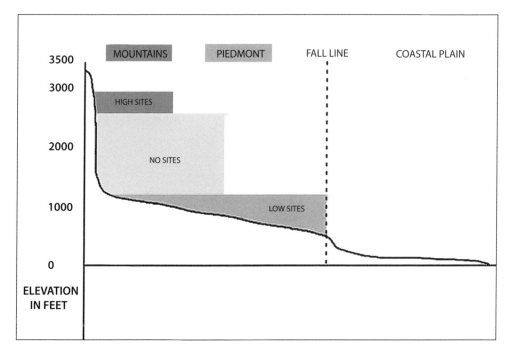

Fig. 7. Approximate elevations at which most South Carolina rock art occurs

Elevations and Landforms

Although far from conclusive, current data indicate that the optimum locations where South Carolina's prehistoric petroglyphs may be found are on two vastly different landforms. One is the mountain crests, where they are found on large bald rock domes; the other is the much lower mountain foothills and Piedmont, where petroglyphs are found on smaller boulders that are primarily located near streams and springs. The mountain crests where rock art was recorded are at elevations of approximately twenty-five hundred feet above sea level or higher. *Lowland* is a relative term here because sites in the foothills and Piedmont were all found at elevations of up to approximately twelve hundred feet (see figs. 7 and 8). Between these two elevation extremes, there is an intermittent zone characterized by steep mountain slopes, an area with many outcrops of large predominately gneiss boulders and a large number of rock shelters—seemingly an ideal location for rock art. Considerable time was devoted to searching among these rock formations, but no rock art was found (see plate 2). Given the frequent discovery of prehistoric pottery and chipped stone in rock shelters on this terrain, the lack of rock art was surprising.

Different Elevations, Different Rock Art

We discovered significant physical differences between petroglyphs found near mountain crests and those located on lowland sites. Most petroglyphs on the high

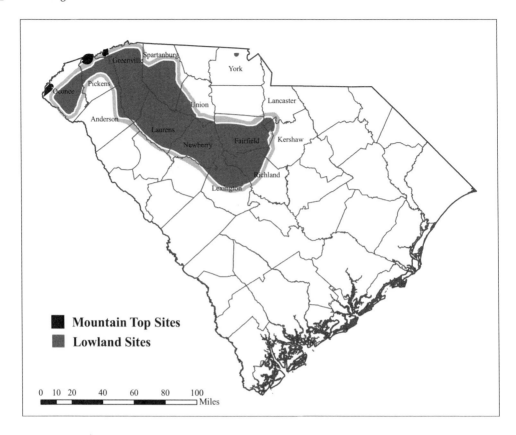

Fig. 8. Areas where high- and low-elevation sites were recorded

elevation sites were boldly pecked into the rock. Although they have suffered considerable erosion, they are clearly identifiable even during periods of bright midday sunlight, a condition under which more highly eroded, or less boldly carved, petroglyphs are invisible. Unlike their highland counterparts, the lowland petroglyphs are almost without exception invisible during the day without some kind of enhancement. We do not know why petroglyphs at the high elevations are more boldly formed than those on the lowland sites. The host rocks at most South Carolina petroglyph sites are gneiss, and it seems logical that, sharing common climate conditions, petroglyphs on the same type of rock should erode at a somewhat similar rate whether highland or lowland. If this assumption is true, then the highland examples may have been more boldly formed to begin with, or they may have been periodically rejuvenated, or they may be of more recent vintage and therefore less eroded than the lowland glyphs; in fact a combination of these factors may apply. Limited survey of high sites on rainy days failed to find evidence of glyphs in a state of near invisibility, like most of those on the lowland sites, but the possibility cannot be excluded that there are such glyphs at highland sites.

Petroglyphs on the Highland Sites

The prehistoric petroglyph motifs represented on the highland and lowland sites are as different from one another as the landforms on which they occur. The highland petroglyphs we found consist predominately of circles that are variable in size and often asymmetrical; a few have lines radiating outward in a "sunburst" manner (figs. 30 and 32). Occasionally a triangle, a square, or another geometric form is carved among the circles, but the great majority are simple circles having no additional attributes (figs. 9 and 29). When we first discovered these sites, the sheer numbers and the repetitiveness of these simple circular motifs gave rise to a degree of skepticism, a belief that they were not a result of human intent but rather the result of some natural occurrence. After careful inspection of other rock domes, both near and at some distance, however, we ruled out the possibility that these circles might be natural. Although similar rock domes occur on all sides of these mountains, our present findings indicate that the circle-dominated petroglyph sites are limited to those rock domes allowing expansive, unobstructed, and predominately westward views. Circle petroglyphs do occur on domes that are oriented north and south, but even on these, the westward views are unobstructed, and landforms having westward views do appear to be preferred for these circles. Then there is the carving of the veins of quartz associated with the host gneiss rock: quartz is much harder than the surrounding gneiss matrix, but despite the marked difference of hardness, the circles are cut through the quartz as well as the gneiss. If the circles had been created by some natural process, the petroglyph grooves would be less deep in the quartz than in the gneiss. Furthermore the rock within the circles' interiors is identical in appearance to that outside the circles. What form of erosion, wearing away a common surface, could create hundreds of doughnut-shaped indentations while leaving the centers intact? These highland domes also have natural circles, which were created by water flowing down the slopes along narrow, shallow depressions or troughs. These dishpan-shaped depressions were formed when the water skipped down the channels "bouncing" from one pan to another (fig. 10). The doughnut-shaped petroglyphs do not occur in these channels, only on the elevated areas between them, and the water-created, dishpan-shaped circles do not occur on adjacent elevated rocks.

Petroglyphs on the Lowland Sites

Displaying a much greater diversity of motifs than those found on mountain crests, lowland petroglyphs varying from simple unadorned circles to complex abstract, anthropomorphic, and zoomorphic forms, as well as cupules (cup-shaped petroglyphs). Cupules may stand alone, be associated with other petroglyphs (figs. 44–47) or be incorporated into petroglyphs by connecting grooves that lead to or through the cupules (figs. 19, 20, 44, and 46). Cupules have thus far not been found on the highland sites in South Carolina, but at a nearby mountaintop site in North Carolina, they are numerous. Given this close proximity, it is reasonable to believe they might also exist at South Carolina highland sites.

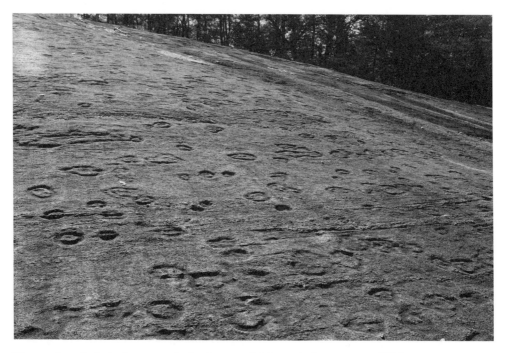

Fig. 9. A typical circle-petroglyph site on a high rock dome, site 38PN122 in Pickens County

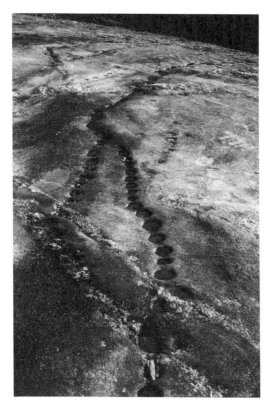

Fig. 10. Natural circles created by water erosion

Lowland site locations are more diverse, and most are associated with rivers, small branches, or springs. This proximity to water is in marked contrast to the highland sites, which are dry except for precipitation. Regardless of the greater overall landform diversity of lowland sites, there appear to be special places where many petroglyphs and the greatest variety of motifs are most likely to be found. Three such sites are 38OC378 in Oconee County and sites 38PN81 and 38PN129 in Pickens County. Each of these sites is on rocks adjacent to low falls or shoals located at the north end of small floodplains, where boldly flowing creeks cascade from higher hills down to the lower elevations. These markedly similar landscapes set themselves apart from all other lowland sites because of the number of petroglyphs and variety of motifs that we recorded in each location. At each site a historic gristmill was later constructed. These three locales are idyllic places where people still congregate.

Historic Petroglyphs

Historic petroglyphs may occur anywhere rock is available. They were found on both high and lowland sites, but like prehistoric petroglyphs, none was found on steep mountainsides or within rock shelters. Some recorded sites had just a single historic petroglyph while others had multiple examples. Sometimes they were associated with prehistoric petroglyphs, but none was associated with pictographs. The majority of historic carvings, some dating to the late sixteenth century, are usually in a better state of preservation than those believed to be prehistoric. Scratching or incising created most, as opposed to prehistoric glyphs, which were with few exceptions created by pecking.

Rock Shelters

Numerous in the mountains, rock shelters diminish in number across the Piedmont, but some can be found southward to the fall line. Evidence of prehistoric occupation was found in some of these shelters on highlands, lowlands, and steep interim slopes. Many seem to offer ideal environments for preservation of rock art, but no petrogyphs were found in them. It is unreasonable to think that petroglyphs were never carved in South Carolina rock shelters or that none remains today, but gneiss rock, in which most of the surveyed shelters were located, can deteriorate at a relatively rapid pace. In many shelters exfoliated rock faces and roof falls were common, and floors were most often strewn with detached rock. Perhaps this natural attrition accounts for the absence of petroglyphs and the paucity of pictographs (plate 2). Nevertheless stable rock surfaces do exist in some rock shelters, and on three of these surfaces pictographs were found (see plates 12–16).

Recording the Sites

We have tried to record each South Carolina rock-art site as completely and accurately as possible under many different, and often difficult, circumstances. Our recording methods were dictated by several factors: the degree of difficulty in reaching a site,

the time available to work there, the physical conditions of the site and the rock art itself, and the difficulty of obtaining GPS data to establish precise locations in some densely forested areas. Consequently our records range from excellent to less comprehensive than we would prefer.

Lowland glyphs can be found, viewed, defined, and recorded only by using procedures that—in places where exposed rock has not suffered the ravages of the southeastern climate—might be considered detrimental to the glyphs. Most South Carolina lowland rock art is eroded almost to oblivion. It can be observed by few people and rarely with the naked eye. It seems inevitable that in the not too distant future, knowledge that they ever existed at all may be dependent solely on the records we create now. Given this bleak prognosis, the decision to do whatever was required to document South Carolina petroglyphs was not difficult, and the value of confirming that they have existed superseded the position that rock art should never be touched or enhanced. Even so we proceeded with as much caution as possible.

To Clean or Not to Clean?

In the forested Southeast, though some rocks have exposed surfaces, many are covered by deposits of soil, plants (particularly poison ivy and poison oak), and roots. These must be removed, and the rocks must be cleaned before one can determined if rocks host petroglyphs (see plates 6 and 7). Obviously this cleaning process involves some risk to any rock art that might be buried there. Justification for the risk of cleaning rocks was demonstrated by the discovery of site 38OC378 in Oconee County, where after removing a mantle of humus and slope wash so that a boulder protruding from a hillside could be inspected (plate 6a), a single petroglyph was uncovered. Then, using a steel probe, we located other buried rocks nearby, and our excavations unveiled many other petroglyphs and cupules. Our risks resulted in the discovery of one of South Carolina's most abundant rock-art sites, which the landowner has since offered to a heritage preservation group.

At two Pickens County sites where we had previously identified petroglyphs on large, only partially exposed rocks, we removed a considerable amount of earth, vegetation, and humus from buried portions of the rocks. At site 38PN81 slope wash had long ago deposited a layer of earth over a considerable part of the rock located immediately adjacent to the forest; small trees, bushes, and other vegetation were well established. After removing this overburden, we used a small pump to supply water from the adjacent stream to wash away the remaining soil. Once or work was completed we found many petroglyphs. Because the rock extends beyond the excavated area for an unknown distance into even more mature forest, it is likely that other petroglyphs also exist there. Presently, however. there are no plans for further excavation. At the second site, 38PN129, an earthen road that was constructed in the early nineteenth century, covered about one third of the known site. Receiving permission to remove the portion of the road covering the rock, we used a backhoe to remove most of the soil. When testing with a steel probe revealed that the excavation

was nearing the rock surface, we discontinued use of the backhoe and washed away the remaining clayey soil with water applied via a pump and hose (plate 6c). Eight previously buried petroglyphs were recorded there.

We cannot accept credit for another excavated site, 38GR306 in Greenville County. There the infamous kudzu vine had completely carpeted a tract of land, but a herd of goats devoured the kudzu in short order, exposing some rather large boulders in the process. Their efforts led to discovery of a single petroglyph and a series of cupules scattered over several boulders. Despite their scampering over these rocks, no obvious signs of damage to the glyphs were observed.

Searching for Petroglyphs at Night

When we conducted our survey on rainy days, the combination of wet rock surface and subdued light sometimes revealed hints of faint lines or grooves in a rock, hinting at the possible presence of petroglyphs. Unable to be sure, we returned to the sites at night for further investigation, using lights placed near and horizontal to the rock surface. This low placement allows the light to skim across the rock, revealing petroglyphs that we could not see by daylight. This method allowed us to determine if the markings we had viewed on a rainy day were petroglyphs or just natural grooves, and we were—with a fair degree of accuracy—able to ferret out and define the forms of many petroglyphs at several sites.

Photography

Because of their virtual invisibility during day, our attempts at photographing lowland petroglyphs were mostly limited to the night hours (plate 8a). No one method of photography suited every situation. Once decent and relatively inexpensive digital cameras became available, we began using them instead of expensive film cameras. We tried different types of lighting, learning that LED and florescent lights produced poor results. Gas lanterns worked for locating glyphs but proved vastly inferior for photography. Eventually we settled on halogen bulbs housed in a reflector that produced a widely dispersed light. But grooves that were revealed when the light was placed in one location were hidden or overilluminated when the light was moved to another; if the rock surface on which a glyph was carved was uneven, the undulations created light and dark areas, or "gaps," across the glyph. We learned to compensate for some of these problems by mounting the camera on a tripod to maintain the camera at a consistent distance from the petroglyph; then we moved the light around the glyph to accentuate different segments, taking a series of photographs at each move (fig. 11). We used a computer-graphics program to select and blend photographs of each of the glyph's visible segments into an acceptable composite image; one example of a photograph produced by this technique is figure 21. Occasionally, even when enhanced with lighting, grooves were too eroded for us to determine if they were cultural or natural. We photographed these "uncertainties," and computer enhanced the images for a closer inspection, but unless a groove could be positively

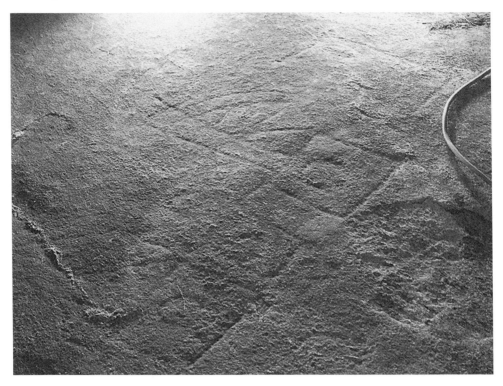

Fig. 11. A petroglyph, invisible by day, revealed at night by using lights to skim the rock surface. Photograph by Jeff Catlin

identified as cultural, it was not recorded as part of a glyph. We used this method to examine all our rock-art photographs, and in several instances we did find additional portions of petroglyphs that we had not recognized in the field.

Preparing the Site for Mapping

Once we established the existence of a nearly invisible lowland petroglyph, most preparation for its documentation had to be done at night. Using lights to ferret out a hidden petroglyph, to define its nuances, and to illuminate it for the photographer works quite well, but the risk of injury in mapping large areas of rock that are precipitous or slippery is too great. After photographing each glyph at night, we applied a thin mix of talc powder and water to the grooves with a soft watercolor brush (plate 8b). An identification number was then assigned to each glyph, and during the daylight, with the enhanced glyphs highly visible, we used a transit to map the site and record each glyph in its proper relation to all others (figs. 12 and 13). The talc is easily washed away, and the petroglyphs again become undetectable. It was often necessary to visit a site several times before we were confident that we had defined all the petroglyphs with reasonable accuracy and had obtained acceptable photographs and other data.

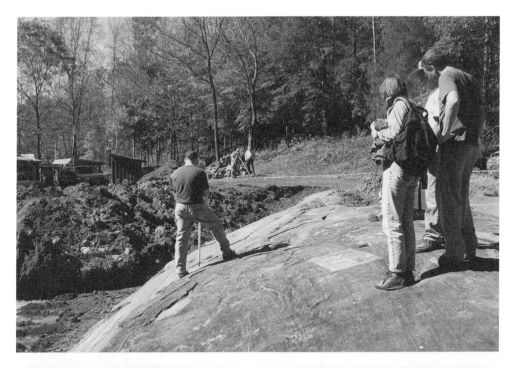

Fig. 12. Mapping excavated site 38PN129 in Pickens County

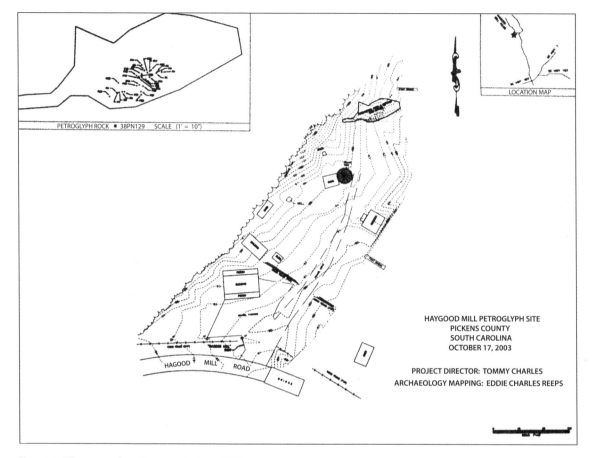

Fig. 13. The completed map of site 38PN129

The Sites Recorded

The Highland Sites

Twelve rock-art sites were recorded near mountain crests. At seven sites we found only prehistoric petroglyphs; two sites have only historic glyphs; one site has both historic and prehistoric carvings; and we could reach no conclusion about the glyphs at one site. One pictograph site was recorded in a rock shelter near mountain crests (see plate 12 and table 1, 38PN102).

Hosting the most visible South Carolina rock art, the mountaintop sites were the most frustrating to document. The time and effort required to reach these isolated areas and short workdays dictated by the necessity of returning to the base of the mountain before dark were major factors. Danger was also a factor. Large numbers of motifs are scattered across expansive—and in some cases steep and dangerous—rock formations that prevent detailed mapping. Because these petroglyphs are in exposed locations and are clearly visible by day, however, we were able to take good

photographs without any enhancement, and we could obtain accurate GPS locations and other pertinent data.

To map all the petroglyphs and the extent of each highland sites completely would have required overnight camping for several days, something for which we were not equipped. Because we were unable to examine the highland sites at night with the lights we used at most of the lowland sites, we cannot say with any degree of certainty that petroglyph motifs similar to those on lowland sites might not also exist on high elevations.

The Lowland Sites

Fifty-two lowland sites were recorded (see table 1). At fifteen we found only glyphs we considered to be prehistoric; eight have both prehistoric and historic glyphs; twelve are historic only; seven are predominately historic but also have markings of undetermined origin; five have only glyphs of undetermined origin; three have prehistoric glyphs and also glyphs of undetermined origin. Seven technically portable glyphs (sites 38GR290, 38GR305, 38GR320 [four glyphs], and 38NE163) were given site status by virtue of having been more recently incorporated into permanent locations. Only three of these fifty-two petroglyph sites are on public lands. Two lowland pictograph sites are among those recorded; one is on publicly owned lands. All other lowland sites are on private lands, and their future protection cannot be assured.

The standard South Carolina Archaeological Site Record form was used to record all sites discovered by the South Carolina Rock Art Survey. These records are on file at the South Carolina Statewide Archaeological Site Inventory Offices, at the South Carolina Institute of Archaeology and Anthropology, University of South Carolina, Columbia.

TABLE 1. ROCK-ART SITES RECORDED IN SOUTH CAROLINA

Site	County	Prehistoric	Historic	Undetermined	Lowland Sites	Highland Sites
Petroglyphs						
1. 38AN227	Anderson	•			•	
2. 38FA303	Fairfield		•	•	•	
3. 38FA305	"	•		•	•	
4. 38FA306	"		•		•	
5. 38FA307	"	•			•	
6. 38GR9	Greenville	•			•	
7. 38GR205	"	•			•	
8. 38GR290	"		•	•	•	
9. 38GR301	"		•			•
10. 38GR303	"	•			•	
11. 38GR304	"		•		•	
12. 38GR305	"		•		•	
13. 38GR306	"	•		•	•	
14. 38GR307	"	•		•	•	
15. 38GR308	"		•		•	
16. 38GR320	"	•			•	
17. 38GR326	"	•	•			•
18. 38GR331	"	•				•
19. 38KE51	Kershaw	•			•	
20. 38LA203	Lancaster	•			•	
21. 38LU422	Laurens	•	•		•	
22. 38LU486	"	•	•		•	
23. 38LU487	"	•		•	•	
24. 38LU488	"	•	•		•	
25. 38LU489	"	•	•		•	
26. 38LU490	"		•		•	
27. 38LU507	"			•	•	
28. 38LX273	Lexington	•				
29. 38NE163	Newberry		•	•	•	
30. 38OC184	Oconee	•			•	
31. 38OC365	"	•				•
32. 38OC378	"	•			•	
33. 38OC383	"			•	•	
34. 38OC384	"		•			•
35. 38OC416	"		•	•	•	

Site	County	Prehistoric	Historic	Undetermined	Lowland Sites	Highland Sites
36. 38PN81	Pickens	•	•		•	
37. 38PN111	"			•		•
38. 38PN121	"	•				•
39. 38PN122	"	•				•
40. 38PN124	"	•				•
41. 38PN125	"			•	•	
42. 38PN127	"	•				•
43. 38PN129	"	•	•		•	
44. 38PN136	"	•			•	
45. 38PN138	"	•				•
46. 38RD668	Richland	•			•	
47. 38SP13	Spartanburg	•			•	
48. 38SP330	"		•	•	•	
49. 38SP331	"		•		•	
50. 38SP335	"			•	•	
51. 38SP336	"			•	•	
52. 38SP337	"	•	•		•	
53. 38SP338	"		•		•	
54. 38SP340	"	•			•	
55. 38SP345	"		•	•	•	
56. 38SP346	"		•		•	
57. 38SP347	"		•		•	
58. 38SP366	"		•		•	
59. 38UN966	Union		•		•	
60. 38UN967	"		•	•	•	
61. 38YK404	York		•		•	

Pictographs

Site	County	Prehistoric	Historic	Undetermined	Lowland Sites	Highland Sites
62. 38PN102	Pickens	•				•
63. 38PN134	"	•			•	
64. 38KE281	Kershaw	•			•	

Rock-Art Motifs

Having been created freehand, each example of rock art is unique. It is relatively easy to categorize motifs that are universal to human understanding, such as representations of animals or humans. On the other hand, much rock art does not clearly convey the intentions of its creators; thus classification is subject to the viewer's interpretation. Attempts to decipher the meaning of ambiguous rock art have produced about as many different opinions as there have been persons viewing it. Unable to know with any certainty what many South Carolina petroglyphs were meant to represent, we simply recorded them as "abstract" or geometric forms; if glyphs seemed suggestive of human or animal forms, we recorded them as possible anthropomorphic or zoomorphic glyphs. Because they were formed by people sharing a culture more contemporary with our own, historic-period petroglyphs usually seemed clearer in intent, and no obviously historic petroglyphs were recorded as abstract.

Anthropomorphic Petroglyphs

Our survey recorded relatively few petroglyphs and no pictographs that clearly represent the human form. Twenty-one human figures were discovered on three sites. Two distinctly human forms were recorded at site 38LU422 (fig. 14) in Laurens County, and eighteen were found at site 38PN129 (figs. 15–17) in Pickens County. A single figure was recorded at site 38SP13 in Spartanburg County (fig. 18). Seven other petroglyphs were recorded as anthropomorph-like figures, but their creators' true intentions are unclear. Site 38LX273 in Lexington County has a single figure (fig. 19); site 38OC378 in Oconee County has two possibly anthropomorphic figures (fig. 20), and four were recorded at site 38PN81 in Pickens County (figs. 21 and 22). All the human and possibly anthropomorphic petroglyphs were discovered on lowland sites. With the exception of three, they are eroded to the extent of invisibility without enhancement.

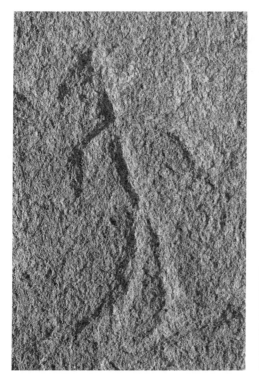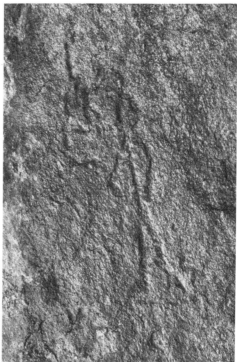

Fig. 14. Human figures at site 38LU422

The Anthropomorphs at Site 38LU422

In concert with several prehistoric and historic petroglyphs, two prehistoric human figures carved in stick form exist at site 38LU422 in Laurens County (fig. 14). These two petroglyphs are highly eroded and totally invisible during the day until just before the sun sinks below the horizon; at that time the low angle of the light skims the rock surface revealing the human forms and several abstract motifs. At night these carvings may be viewed by placing a light near the rock surface to replicate the sun's low position at sunset. At this site the petroglyphs known to be historic consist of names, initials, and dates and, unlike the prehistoric glyphs, they are clearly visible even during brightest daylight. A portion of this site is now covered by a recently created man-made lake. Other carvings are said to exist below the water, but their existence has not been confirmed.

The Human Figures at Site 38PN129

The largest numbers of petroglyphs depicting the human form were discovered at site 38PN129 in Pickens County. Eighteen human figures, predominately males,

were pecked into a large low-lying boulder. Our first inspection of this rock resulted in the recording of only a single, small, dissected square that we then thought to be of historic origin. At a later date, one of our survey volunteers, Michael Bramlett, was driving by the site on a rainy day and decided to investigate the rock again. Because the rock was wet and the light subdued, he was able to identify several small, barely visible, human figures carved into the rock (fig. 15). Subsequently we visited the site at night, and with the use of lights to skim the rock surface, we were able to better identify the glyphs that Mike had observed and to see others that had remained invisible by day. At this point our count of human figures at this site had risen to twelve.

A large portion of the rock lay buried beneath a dirt road that was constructed during the 1820s, the first public road between Pickens, South Carolina, and Rosman, North Carolina. Curious about what carving might be buried beneath the road fill, we requested and received permission from Pickens County and the property manager, the Pickens County Museum, to remove the portion of the road that covered the rock so it could be examined in its entirety. After the red-clay road was excavated, the City of Pickens offered a truck with a water tank and pump that we used to wash the residual soil from the rock. After cleaning the rock, we found six additional human figures and two abstract petroglyphs that had been hidden beneath the excavated roadbed. Four of the newly discovered glyphs are male figures enclosed in individual squares; each square has a small cupola, or domelike enclosure, on top. Three of these human figures are grouped side by side (fig. 16) while the fourth

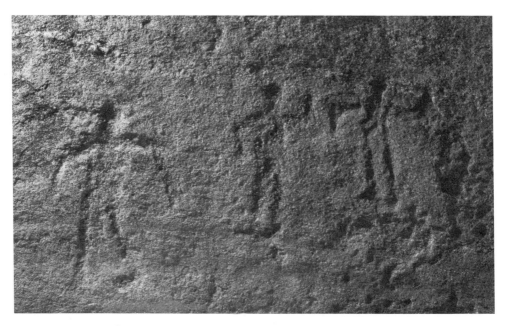

Fig. 15. A group of three of the human figures at site 38PN129. Photograph by Brian Johnson

29

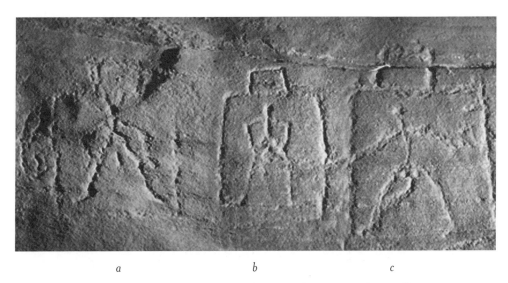

a b c

Fig. 16. Male figures in enclosures at site 38PN129 (digitally enhanced).
Note appendages on head of figure *a*. Photograph by Lezlie Barker

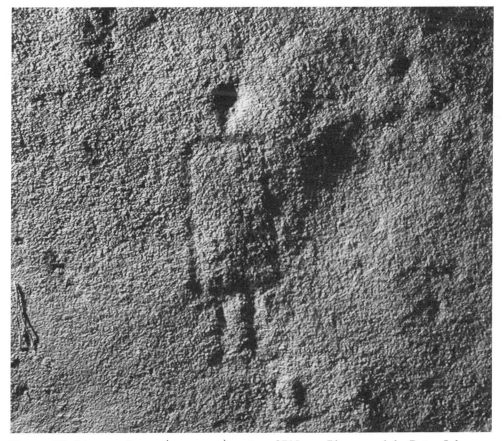

Fig. 17. "Refrigerator" man (or woman) at site 38PN129. Photograph by Brian Johnson

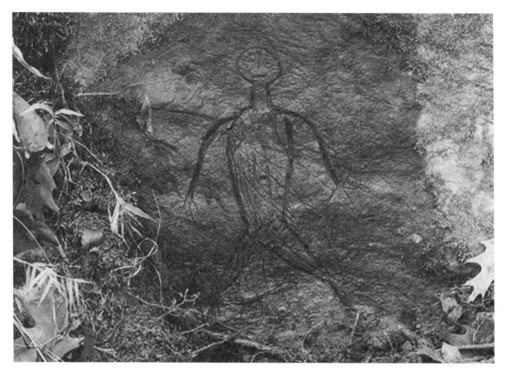

Fig. 18. The human figure at site 38SP13 in Spartanburg County
(digitally enhanced)

stands alone. The stand-alone figure is much more eroded than the three grouped
figures. Heads for the bodies are represented by small cupules. One head has two
hornlike appendages (fig. 16a); no others are so adorned. Although no absolute date
can be assigned to the petroglyphs, the known date for the road construction estab-
lishes that the buried glyphs predate that event. The carvings that were buried are in
a better state of preservation than those long exposed.

With a single exception, the human motifs are sticklike figures. The exception
is a figure with head and legs but no arms and with a torso in the form of a rectan-
gle (fig. 17). Accompanying the prehistoric human and abstract figures are two his-
toric petroglyphs consisting of a set of initials and the name "Thomas." The historic
glyphs are further distinguished by their greater visibility and their method of manu-
facture, which was scratching or incising rather than the pecking used to create all the
prehistoric petroglyphs. No historic carvings were found beneath the old roadbed.

The Anthropomorph at Site 38SP13

A single human figure was recorded at site 38SP13 in Spartanburg County (fig. 18).
The area encompasses a huge prehistoric steatite quarry whose use dates back to the
Late Archaic period, some four thousand years ago. Many stone bowls and fragments
of bowls have been found there. Although many have been removed, some may still

Fig. 19. The single anthropomorph-like petroglyph at site 38LX273
in Lexington County

be observed at the site in various stages of completion. There are a few historic ini-
tials carved on boulders, and only two glyphs might be of prehistoric origin. One is
a figure of a human with some birdlike attributes. The glyph is on a vertical wall of a
steatite boulder located immediately by a river and just above ground level. Its close
proximity to the ground is probably a result of erosion from the adjacent hillside
that may have buried the rock to its present depth. The glyph's body and limbs are
well defined, but the many scratches over and around the body create a birdlike
feathering effect. It is conceivable the carving is a composite; the bold body could
have been incised by one person, and at some later date, another person might have
applied the scratches. This possibility, however, can not be confirmed with any cer-
tainty. When the glyph was reported, it was covered with a thin layer of green moss,
and the small scratches were not apparent. When we revisited the site a short time
later, the moss had been removed, revealing the small incisions. Fortunately the glyph
itself showed no obvious damage. It is one of the few lowland glyphs that may be
observed by light of day and without enhancement.

The Anthropomorph at Site 38LX273

A single, possibly anthropomorphic figure represents the only petroglyph at site
38LX273. It is the only example of rock art presently recorded in Lexington County

(fig. 19). Two cupules are incorporated into the carving, one representing the "head" and another placed about where the pelvis should be. The carving is visible during the day, but light filtering through the trees cast shadows over the petroglyph making it difficult to see and even more difficult to photograph. Of the many photographs we took, the only ones that captured the carving were those taken under a sheet of black plastic with the use of a flash to sidelight the petroglyph. This site narrowly escaped destruction when a new roadway was cut through the forest for a housing development, missing the boulder by approximately ten feet. This petroglyph is one of only two recorded this far south in South Carolina.

The Anthropomorphs at Site 38OC378

At site 38OC378 in Oconee County two anthropomorph-like figures have been pecked into the top surface of a large gneiss ledge that protrudes from a hillside. These are the most boldly carved of the anthropomorphs recorded by the survey and among the few prehistoric petroglyphs on a lowland site that can be observed during the day regardless of light conditions (fig. 20). Associated with the anthropomorphs are several cupules, some less visible abstract motifs, and a single glyph in a style often referred to as a "bird track." A series of cupules in a line across the front of the ledge appear responsible for a portion of the rock having broken away along the line—a breaking pattern similar to that created when a modern drill is used to break apart a large boulder along a predictable line, as in a quarry. Because the break was old and weathered equally with the other rock, we were at first unaware that a portion of the ledge had broken away and that the ground on which we were standing was actually the collapsed portion of the ledge, now covered by a layer of dirt and humus. The fallen portion was discovered when, after several visits, we became aware of the possibility that rocks of substantial size might also be buried beneath the forest floor. To test this assumption, we used a steel rod to probe the area and discovered several buried rocks, one of which proved to be a portion of the ledge that had broken away along the line of cupules. After we cleaned this collapsed fragment and a nearby smaller rock—which may also have been a portion of the same ledge—we found several glyphs on them. The intact rock ledge could well have served as a small habitat for humans. After breaking away from the host rock, the two rocks on the ground, located at the base of a hill, were buried by soils eroding from the adjacent hillside and by the natural accumulation of humus. By the mid–nineteenth century most of the elevated landforms in the Piedmont of South Carolina had been denuded of topsoil because of erosion caused by land clearing and agriculture. Consequently many archaeological sites are now buried at the bases of hills and on floodplains. Site 38OC378 is one of three (along with sites 38PN129 and 38PN81) where additional petroglyphs were discovered by excavating buried portions of the rock or other buried rocks immediately adjacent. These discoveries emphasize the possible rewards of examining other subsurface rocks close to known petroglyph sites.

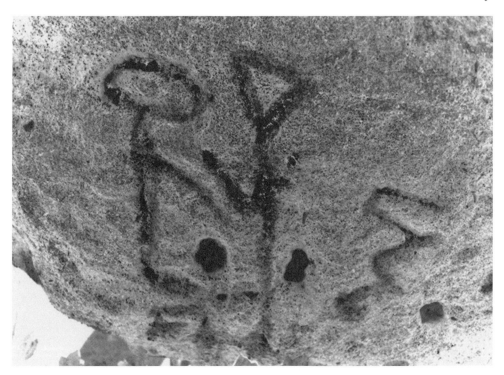

Fig. 20. Two anthropomorph-like petroglyphs at site 38OC378 in Oconee County (digitally enhanced)

The Anthropomorphs at Site 38PN81

There are four carvings suggestive of the human form at site 38PN81 in Pickens County. Three figures are included in a single panel (fig. 21), and the fourth stands alone (fig. 22). None is visible by day, and even with nighttime lighting to accentuate the carvings, it is difficult to define every attribute accurately. Much of the middle form shown in figure 21 has apparently eroded away, and the remaining portions are barely visible. Because of the undulating lie of the rock, observing or photographing all parts of the three-figure glyph simultaneously was virtually impossible. To capture it in its entirety, we created a composite from a series of photographs (fig. 21).

The fourth anthropomorph (fig. 22) is equally obscure and smaller than the panel of three. Situated on a more uniform surface, it was easier to photograph and did not require the blending of separate images into a composite. With the exception of these four possibly anthropomorphic figures, most of the glyphs at this site are abstract forms. Like the anthropomorphs, these abstract glyphs are considered to be prehistoric. The site also has some historic glyphs consisting of names and initials. With a total of 198 petroglyphs, site 38PN81 contains the greatest number of petroglyphs recorded on any lowland site.

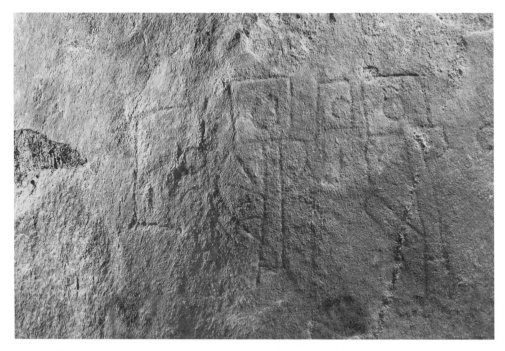

Fig. 21. Three of the suggestive anthropomorphic figures at site 38PN81 in Pickens County (digital composite). Photograph by Lezlie Barker

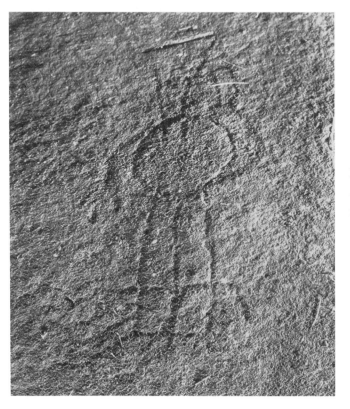

Fig. 22. The fourth anthropomorph-like figure at site 38PN81 (digitally enhanced)

a.

b.

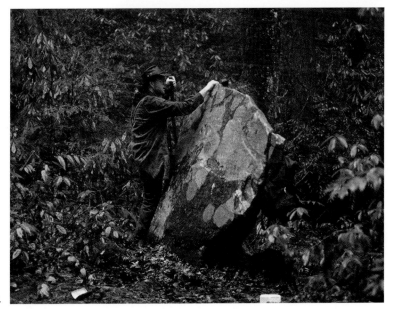

c.

Plate 1. Volunteers searching for rock art. Only modern-day graffiti was found on this bright sunny day (*a*), but rainy days (*b* and *c*) were good times to find highly eroded petroglyphs.

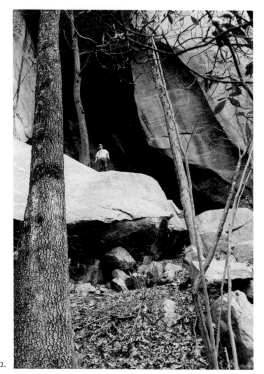

a.

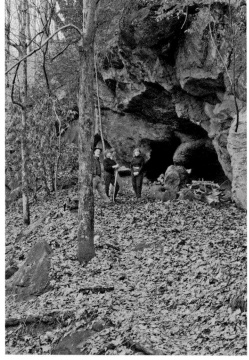

b.

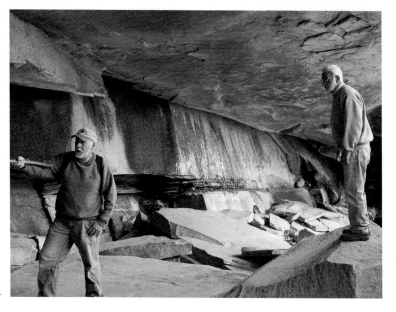

c.

Plate 2. Examples of the many rock shelters we explored during our survey. Dennis Chastain and Paul Blessing are shown in photograph c.

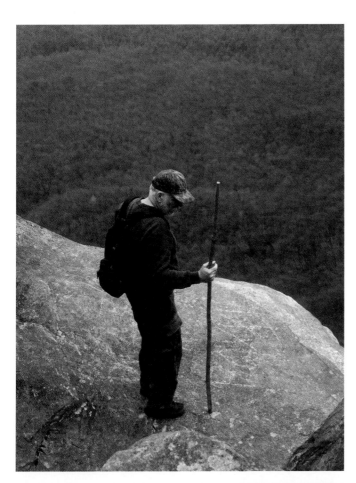

Plate 3. Searching for rock art near mountain crests (*left:* Dennis Chastain; *below:* Tommy Charles with Dr. Cato Holler and Dennis Chastain in background; photograph Leslie Barker)

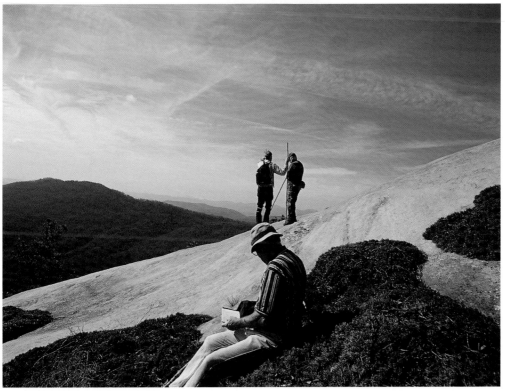

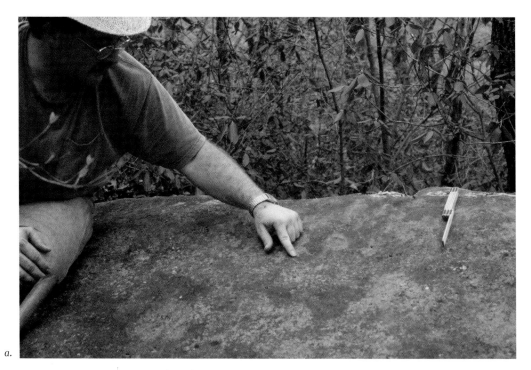

a.

Plate 4. Michael Bramlett (*above*) pointing to a groove he found in daylight while eating lunch on a rock at site 38OC384. When we covered the rock with black plastic to simulate night conditions and used lights to skim over the surface (*below*), we could detect the presence of carving but were unable to define and photograph it adequately.

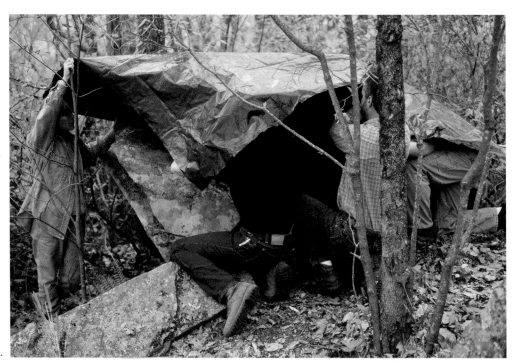

b.

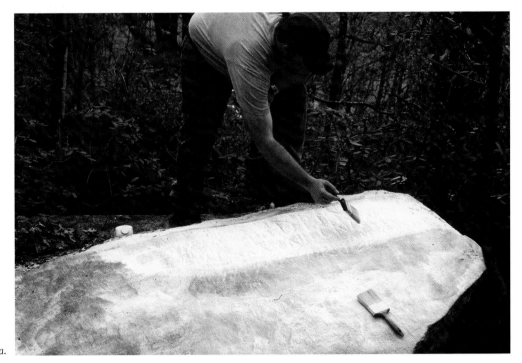

a.

Plate 5. Michael Bramlett spreading dry talc powder over the rock at site 38OC384 (*above*) in Oconee County. After the excess powder was brushed away (*below*), we discovered alphabet-like petroglyphs that spelled nothing.

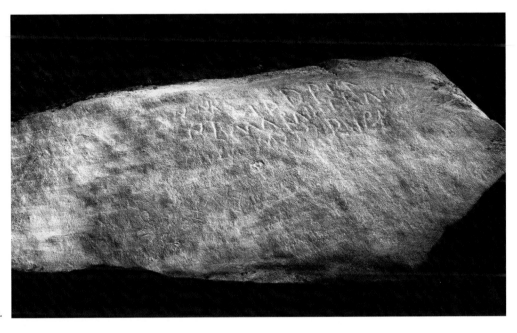

b.

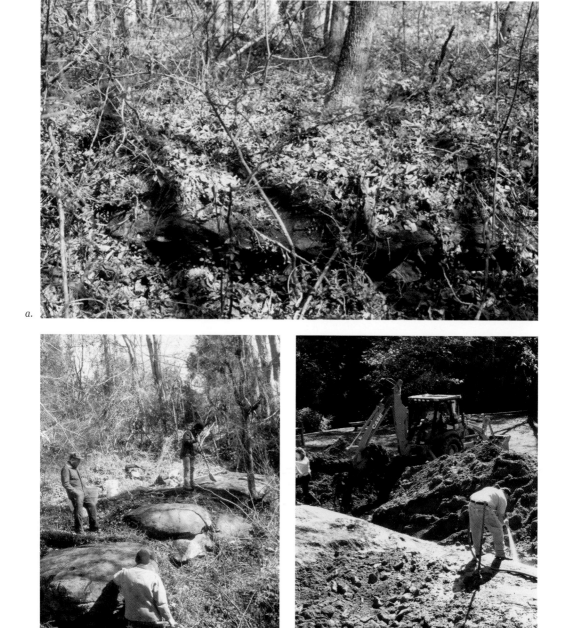

a.

b.

c.

Plate 6. Rock outcrop covered with humus at site 38OC378 in Oconee County (a); after cleaning this and adjacent rocks, we found one of the most prolific petroglyph sites in our survey. After removing the humus layer at site 38GR307 in Greenville County (b), we found two petroglyphs. Removing an old road (c) that covered a portion of the known rock-art site 38PN129 in Pickens County, we found eight additional petroglyphs beneath the roadbed.

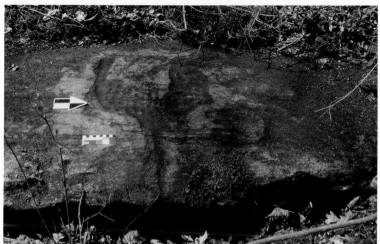

Plate 7. Some of the petroglyphs we discovered after removing soil and forest humus from host rocks at sites 38GR307 in Greenville County (*top*), 38OC378 in Oconee County (*middle and bottom right*), and 38PN81 in Pickens County (*bottom left*)

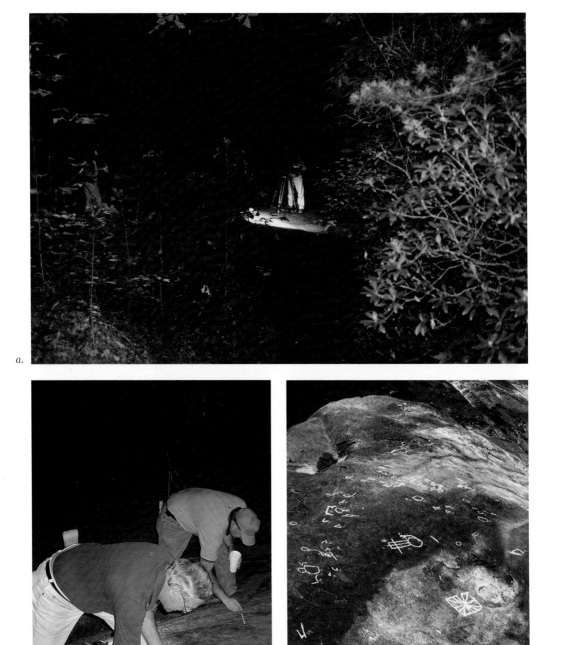

a.

b.

c.

Plate 8. Nighttime photographing of petroglyphs using artificial light at site 38PN81 in Pickens County (*a*). Tommy Charles and Michael Bramlett tracing petroglyphs with talc powder at site 38PN129 (*b*), also in Pickens County, to make them visible during the day. The petroglyphs at site 38PN81 after they were traced with talc powder (*c*).

Zoomorphic Petroglyphs

Zoomorphic figures are remarkably scarce in South Carolina rock art. We recorded only five petroglyph and two pictograph sites having motifs that might represent animal or insectlike forms.

The Zoomorphs at Site 38LU422

At site 38LU422 in Laurens County, we found one carving suggestive of a quadruped, and possibly another (figs. 23 and 24). One is problematic because it is part of a larger abstract form, and its zoomorphic appearance may be fortuitous (fig. 24). Both glyphs are highly eroded and totally invisible for most of the day, but they may be observed just before the sun vanishes below the horizon, when the low light skimming over the rock surface creates shadows that accentuate the otherwise invisible grooves. These conditions may be replicated by using lights at night; yet the natural light of late day produced the conditions for our best photographs, figures 23 and 24. These zoomorphs are associated with two human figures that are equally eroded and also considered to be prehistoric.

The Zoomorph at Site 38OC184

Site 38OC184 in Oconee County has a single petroglyph, a turtle motif that was created by incising rather than the more common method of pecking (fig. 25). The glyph is in a precarious location, immediately next to the Tugaloo River on one side and a narrow dirt road on the other. Because of its close proximity to the road, the

Fig. 23. A possible zoomorphic motif at site 38LU422 in Laurens County

Fig. 24. Incorporated into a complex of grooves, this motif at site 38LU422 could be a zoomorph or part of a larger abstract design

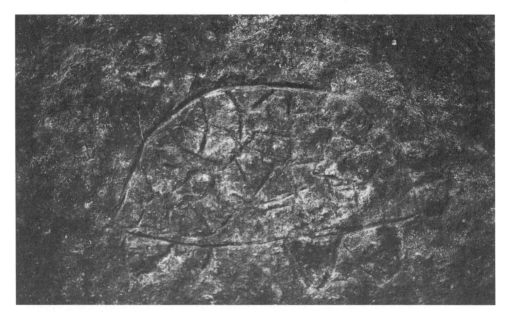

Fig. 25. Turtle at site 38OC184 in Oconee County

site is endangered. The area is rapidly becoming developed, and increasing vehicle traffic has resulted in damage to the turtle's head, a portion of which has been abraded away by the tires of vehicles that brush against the rock. Recorded in 1983, this petroglyph was thought to be the first example of rock art reported in South Carolina. It was actually the second, the first (fig. 2) having been recorded by Dr. Robert L. Stephenson four years earlier. No cultural affiliation with the Cherokee can be inferred for this petroglyph, but the site is located in the last parcel of land that they ceded to the State of South Carolina on March 22, 1816.

The Zoomorph at Site 38RD668

In a thickly settled old neighborhood in the heart of Columbia, South Carolina, there is a large granite boulder with a beetlelike image boldly pecked into its vertical face (fig. 26). Locals call it the "King Beetle Rock," and some older people can recall playing around the rock as children. No one knows the glyph's origin, but it is presumed to be prehistoric. It is the only petroglyph recorded in Richland County and one of the two southern-most petroglyphs recorded in the state. Because this petroglyph and the anthropomorphic figure at site 38LX273 (fig. 19) in adjacent Lexington County are both visible by day without any enhancement, they are anomalies for lowland sites. A reason for this may be that these two rocks are granite rather

Fig. 26. The "King Beetle" zoomorph at site 38RD668 in Richland County

Fig. 27. Serpentlike petroglyphs at site 38PN81

than gneiss, which serves as host for most rock art. Perhaps granite weathers less rapidly.

The Zoomorphs at Site 38PN81

Two serpentlike motifs were recorded by the survey, both created by pecking at site 38PN81 in Pickens County (fig. 27). Like all other prehistoric petroglyphs at this site, they are extremely eroded and totally invisible by daylight. They were discovered when we were using lights at night.

An Oddity at Site 38PN138

Located on one of the mountaintop sites in Pickens County (38PN138), this petroglyph was discovered and photographed by volunteer Jeff Catlin while he was hiking (fig. 28). We cannot determine if its creator intended it to be zoomorphic or if a fortuitous combination of circles and lines just happen to resemble a turtle or some other creature. Like many other petroglyphs on highland sites, it is quite visible by day and without enhancement.

Abstract Motifs

The overwhelming majority of South Carolina petroglyphs consist of forms that were recorded as abstract motifs. The simple circle is the most abundant. Predominately

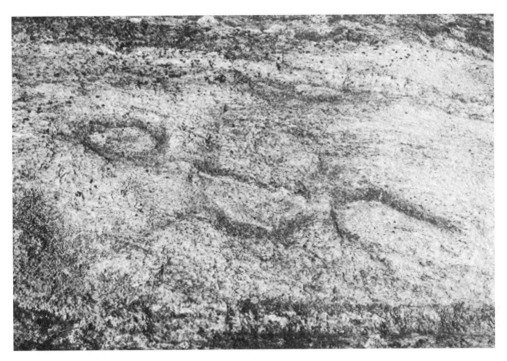

Fig. 28. Turtle or a random combination of lines and circles at site 38PN138 in Pickens County. Photograph by Jeff Catlin

found in Pickens County, circle glyphs most often occur in dense concentrations on bald rock domes that are on or near the highest elevations of mountain peaks (fig. 29). Circles are infrequently found on lowland sites, where a diversity of other abstract forms are more abundant. These forms are too numerous to illustrate in their entirety. Examples of their variety are presented in this chapter.

Abstract Motifs on the Highland Sites

Circles at Site 38PN122

Hundreds of circles—and no other forms—were found on this sloping rock dome in Pickens County. The site is the first we discovered where petroglyphs were so boldly carved that they were easily observed by daylight. There is no obviously deliberate patterning of the circles. They are less numerous approaching the timberline at the top of the dome, and they also decrease in frequency near the timberline on the lower portion. The reason for the concentration of circles at the midsection of the rock dome is not apparent, but it is possible that, when the glyphs were carved, the high and low portions were covered by a thin veneer of soil, which still covers much of the rock today. This is one of several similar sites that have been discovered in a relatively restricted area of Pickens County. Why so many redundant circles are on these particular rock domes and not on many similar ones, has not been determined.

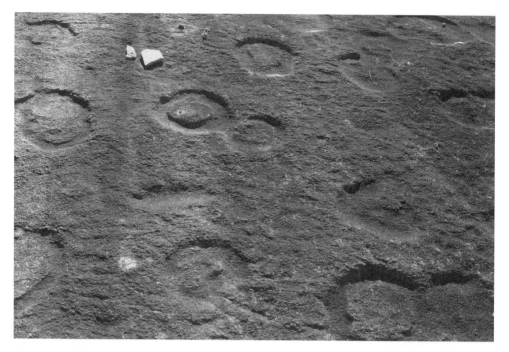

Fig. 29. Bold circles at site 38PN122 in Pickens County, one of several similar sites we found on high rock domes

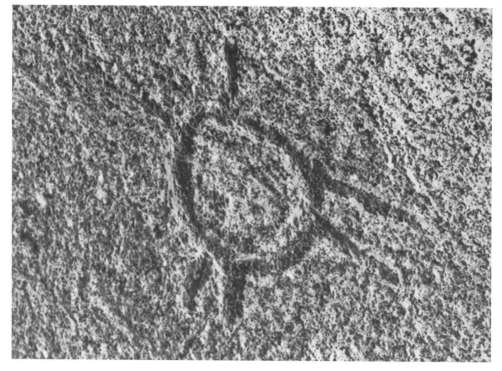

Fig. 30. Circle with outward-radiating lines at site 38PN127 (digitally enhanced)

Abstract Petroglyphs at Site 38PN127

Only two petroglyphs were recorded at site 38PN127 in Pickens County. One is a simple, faintly visible circle; the other is a slightly more visible circle with six outward radiating lines (fig. 30). The six lines are unusual because they are paired in groups of two. Another oddity is that the circles at this site were the only circles we found on an east-facing rock dome. Their limited number, their east-facing location, and the paired lines on the more-visible circle set this site apart from all the other high-elevation circle sites that we recorded.

Abstract Petroglyphs at Site 38PN121

Also in Pickens County, site 38PN121 is located on a sharp, narrow rock spine that leads to the slightly higher "circle" sites. Enclosed on both sides by low forest, the site lacks the expansive vistas typical of most of the high-elevation sites. Site 38PN121 is also the smallest in area of all the highland sites we found. Unlike other nearby sites, it is the only one exhibiting any marked degree of motif variance. Most circles at this site have outward-radiating grooves, or they may be dissected by interior grooves. Some are joined by grooves to other motifs, forming complexes (figs. 31 and 32). Several petroglyphs stand alone and consist of grooves that form irregular squares and rectangles or randomly meandering lines. All the glyphs at this site are less visible than those on nearby sites. We could not determined if they are more eroded than nearby glyphs or if they were just never as deeply pecked into the stone.

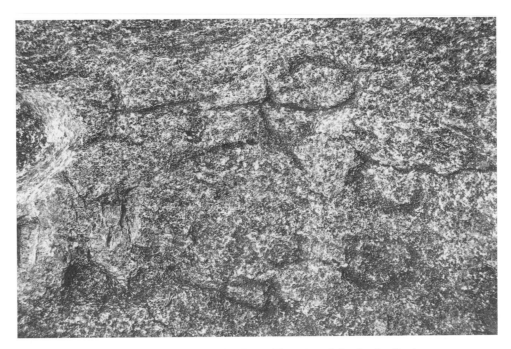

Fig. 31. Abstract petroglyphs at site 38PN121. Photograph by Lezlie Barker

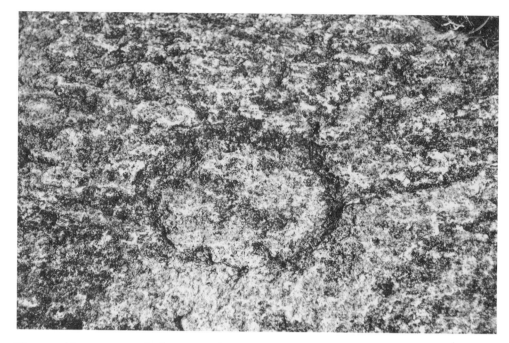

Fig. 32. Abstract petroglyph at site 38PN121. Photograph by Lezlie Barker

Abstract Petroglyphs on the Lowland Sites

The Abstract Petroglyphs at Site 38PN81

The greatest number of abstract petroglyphs on a lowland site, 169, was recorded at site 38PN81 in Pickens County. Erosion has reduced the petroglyphs to a state in which they are invisible during the day. When it is raining, however, a few faint images may be observed, and it was on such a day that the site was discovered. Even with the rain, we were unable to define the glyphs adequately by day; we subsequently explored the site at night with lights. The glyphs were so eroded that only by diligent use of artificial light directed from different angles and elevations were we able to determine their shapes and physical conditions. Multiple inspections of each petroglyph were necessary to ensure that natural lines were not being confused with those created by humans. We worked late into the night on many occasions. Because of their eroded condition—and in some cases their position on uneven rock—obtaining clear photographs was difficult, and some digital enhancing was necessary. A selection of these photographs is shown in figures 33–40.

The Abstract Petroglyphs at Site 38PN129

Site 38PN129, which has more human figures than all other recorded sites combined, has relatively few abstract glyphs in contrast with other sites. The abstract motifs are also eroded to a greater extent than most of the human forms. The two glyphs illustrated in figures 41 and 42 are the only ones of which we were able to obtain decent

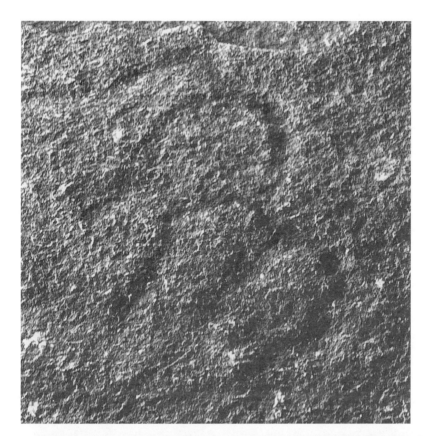

Fig. 33.
Abstract petro-
glyph at site
38PN81
(digitally
enhanced)

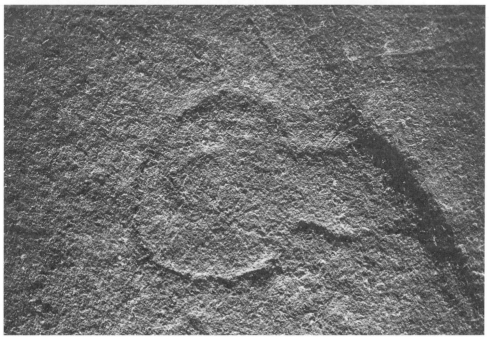

Fig. 34. The "keyhole" at site 38PN81 (digitally enhanced)

33 cm

32 cm

Fig. 35. Drawing of an abstract petroglyph at site 38PN81

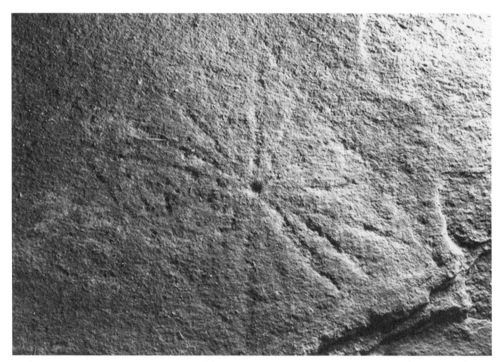

Fig. 36. The "flag" at site 38PN81. Photograph by Jeff Catlin

45

Fig. 37. Abstract
petroglyph at site
38PN81 (digitally
enhanced)

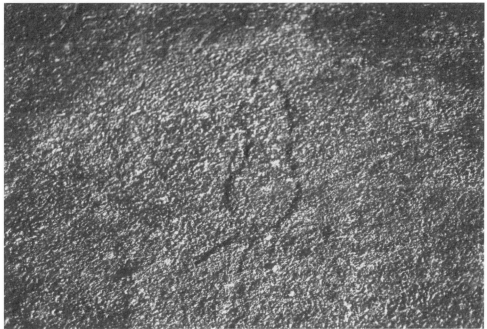

Fig. 38. Abstract petroglyph at site 38PN81 (digitally enhanced)

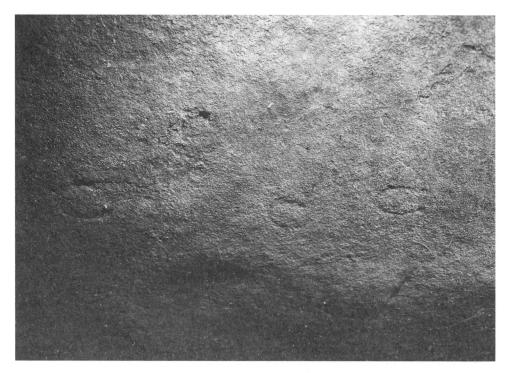

Fig. 39. The "horseshoes" at site 38PN81 (digitally enhanced)

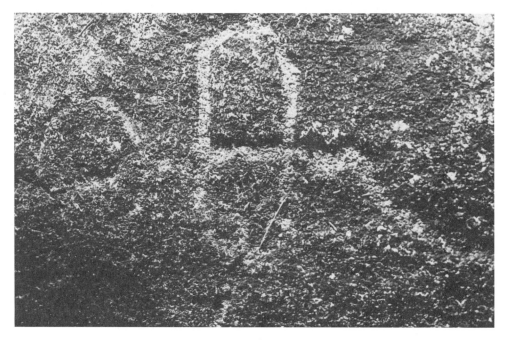

Fig. 40. Abstract petroglyph at site 38PN81 (digitally enhanced).
Photograph by Eugene Crediford

photographs. They were photographed at night by side scanning with lights, and then the images were digitally enhanced. As with the human figures at this site these abstract forms were created by pecking.

The Abstract Petroglyphs at Site 38LU422

Partially inundated by a recently constructed lake, most of the petroglyphs at site 38LU422 in Laurens County are extremely eroded. Difficult to see under the best of circumstances, the prehistoric carvings can be observed only at night by using lights or just before dark as the sun sets and the low angle of sunlight skims the rock surface. The photograph in figure 43, taken at sunset, is the best image of a prehistoric glyph that we were able to capture at this site; it has been digitally enhanced. Eroded sites such as this are examples of why it is so difficult to find South Carolina rock art and suggest how much has surely been lost or remains to be discovered.

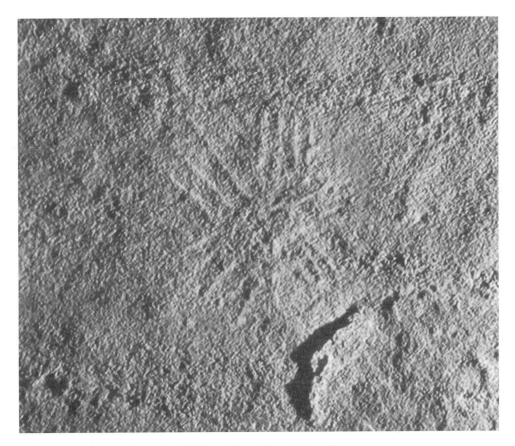

Fig. 41. The "waffle" at site 38PN129 (digitally enhanced)

48

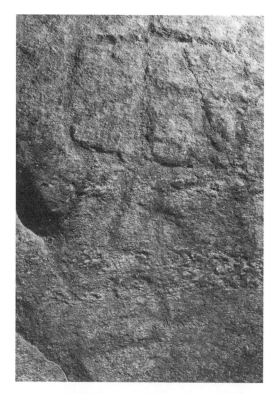

Fig. 42. Abstract petroglyph at site 38PN129 (digitally enhanced)

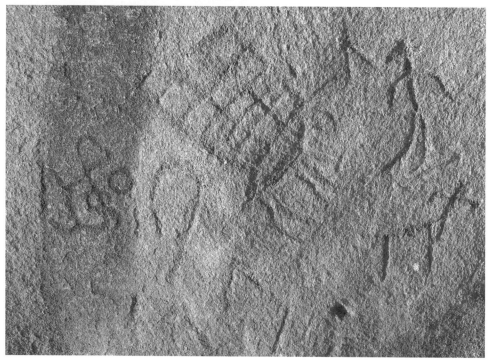

Fig. 43. Abstract motifs with an anthropomorph and possible zoomorphs at site 38LU422 (digitally enhanced)

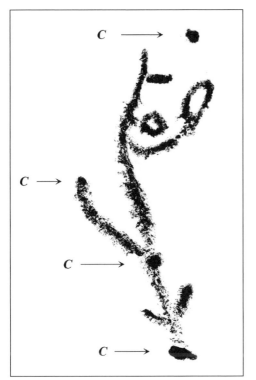 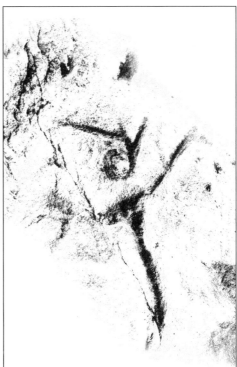

Fig. 44 (*left*). Cupules incorporated in an abstract petroglyph at site 38OC378
(*C* = cupule)

Fig. 45 (*right*). Abstract petroglyph at site 38OC378

The Abstract Petroglyphs at Site 38OC378

Site 38OC378 in Oconee County was "buried" and discovered by sheer luck. Having searched the east bank of a stream all morning and finding not a scratch on the many exposed rocks, we crossed the stream to explore the opposite shore, where we came upon a rock protruding from a hillside and almost hidden by slope-washed soil, vines, and humus. Such outcrops exist by the thousands, and because they require considerable cleaning before they can be inspected, most are ignored. On a very casual inspection, however, we spotted a small vertical groove that ran contrary to the rock's natural horizontal orientation. By hand we removed the vines and humus so we could examine the "abnormal" vertical groove, which proved to be a portion of a petroglyph. We later returned to the site with tools to cut through large roots and vines, and with buckets to carry water for cleaning the rock. Eventually fifteen large boulders were found and uncovered. After cleaning, most of the rocks appeared to be void of petroglyphs, but by using lights to inspect them at night, we found extremely eroded petroglyphs on several. The precarious physical condition of South Carolina petroglyphs was clearly illustrated here. The surfaces of several

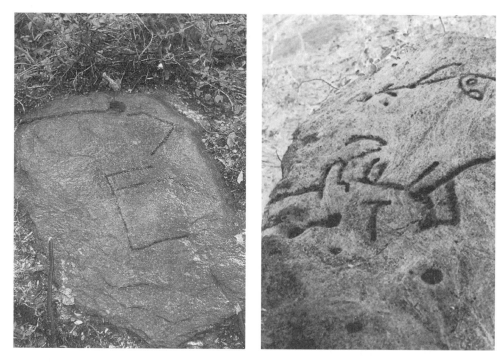

Fig. 46 (*left*). Buried cupule and lines discovered by probing at site 38OC378

Fig. 47 (*right*). Abstract petroglyphs and cupules at site 38OC378

rocks were so decomposed that a thin veneer could be removed by pinching with a person's fingers. Four boulders had abstract petroglyphs and cupules that are considered prehistoric; one had three cupules but no other carvings, and another had a single circle-and-line petroglyph of undetermined antiquity. These glyphs are among the few recorded that have cupules. Although visible by day, a few other glyphs are almost impossible to photograph except by using lights at night. We were unable to obtain photographs that would adequately present the petroglyphs shown in figures 44–49, so each has been digitally enhanced.

The Abstract Petroglyphs at Site 38GR303

Chance discoveries of archaeological significance that are totally unrelated to the purpose at hand are not uncommon. So it was that petroglyph site 38GR303 in Greenville County was discovered. An elderly woman contacted the SCIAA and requested that an archaeologist visit to inspect an old spring that, when she was a child, had been covered with a stone alcove to protect it. All her family's water needs were met by the spring. She had fond memories of the days when they washed clothes by the spring as the children played there. She had not visited the spring in many years and, wanting to visit it again, thought it might be of some historic interest to SCIAA.

Fig. 48 (*left*). Buried abstract petroglyph discovered by probing at site 38OC378 (digitally enhanced)

Fig. 49 (*right*). Buried abstract petroglyphs discovered by probing at site 38OC378 (digitally enhanced)

The area was now cloaked in mature forest, and my companion was dismayed to find that the stone alcove had collapsed. Now a pile of rubble, the alcove was partially covered with soil that had eroded downhill and overgrown with brush and vines. In an attempt to offset her disappointment at this negative turn of events, I told her about the rock-art survey I was conducting and suggested we examine some of the nearby rock outcrops to determine if they might host petroglyphs. About twenty-five meters from the spring was a small boulder not elevated greatly above ground level. The rock was covered with an unusual group of faintly incised abstract petroglyphs. They are unusual because of their forms and also because they were created by incising instead of the pecking that is more common in prehistoric glyphs (fig. 50). Accompanying the glyphs are twenty-three shallow holes measuring approximately 5–7 mm in width. The holes appear to have been drilled into the rock, but since they are somewhat eroded, I could not be determined if they were made using a hollow cane (a common prehistoric drilling method) or a solid shaft. We were both elated by this chance discovery.

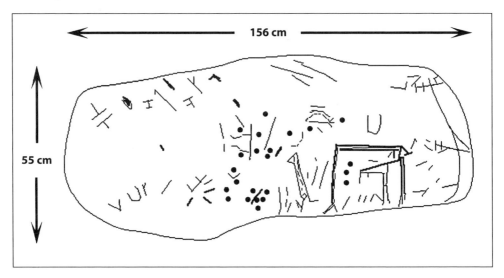

Fig. 50. Sketch of abstract petroglyphs and small, drilled holes at site 38GR303

The Abstract Petroglyphs at Site 38GR320

One of the more interesting sites consists of four petroglyphs incorporated into a stone wall that encloses a church cemetery in Greenville County. The church dates to 1786, and the earliest marked burial is dated 1791. A new portion was added to the older cemetery wall about 1932, and the stone for the addition, collected locally, was brought to the church in wagons. Among the rocks were four stones carved with petroglyphs. No one today knows the exact origin of these rocks. Obviously the builders of the wall addition recognized the glyphs and placed them side-by-side adjacent to the entrance gate. Although visible by day, the glyphs are difficult to photograph, and the photographs in figure 51 were taken at night. Three of the glyphs were created by pecking, and the method used for the fourth (fig. 51d) is undetermined. It appears that it could have been pecked and then had its grooves smoothed by rubbing. It is possible that these four glyphs were originally from larger boulders, or perhaps they were cut from a single large rock. Because the size of the stone or stones that once hosted these glyphs is unknown and because they are now in a permanent location, they are not considered to be portable. They are believed to be prehistoric in origin.

The Cupule Site: 38FA305

The only site prolific with cupules was recorded in Fairfield County. More than two hundred were found randomly placed on several flat, immediately adjacent sheet rocks near ground level (fig. 52). One larger depression, like a mortar, is among them. With this single exception, the cupules are small but varying in size, shallow but

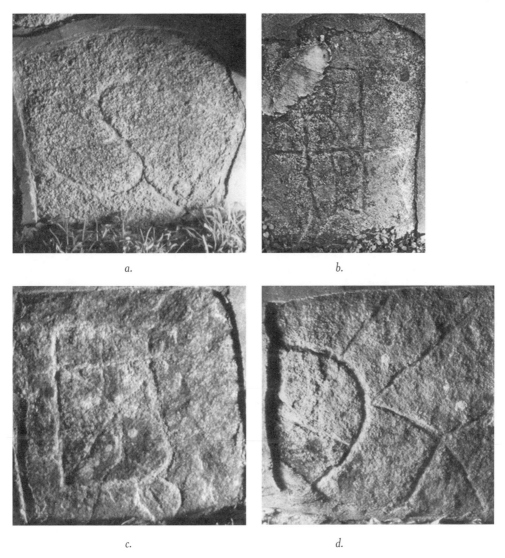

a.

b.

c.

d.

Fig. 51. Petroglyphs incorporated into a wall surrounding a cemetery at site 38GR320

of different depths. A short distance away are two rocks elevated above ground level; on top of these and on their vertical faces, are a few similar, random, cupules. These cupules exhibit the same size and depth patterns as those on the ground-surface sheet rocks. It cannot be said with certainty if these cupules are prehistoric or historic, but they are obviously not a result of historic drilling for the purpose of quarrying rock. Quarrying of granite was once common in the region, and from observing the holes left by that process, we know that the drills used by the quarriers were quite a bit larger in diameter than tools used to create these small cupules. The modern

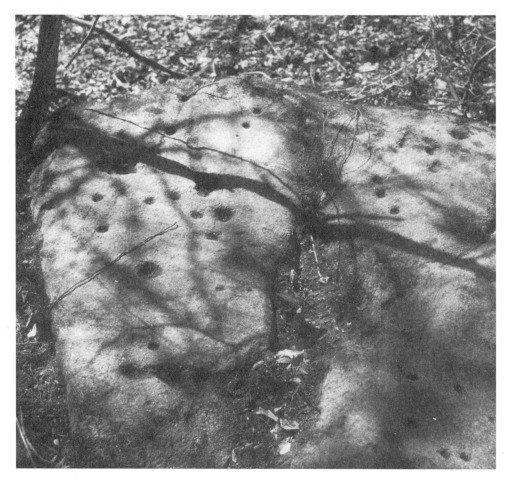

Fig. 52. A few of the many cupules at site 38FA305

methods of drilling left distinct in-line patterns necessary to cleave the rock precisely, and the holes are uniform in size. The small cupules at site 38FA305 are randomly distributed, and their surface edges are more worn and irregular, as if formed by a tool other than a drill bit.

Abstract motifs are not only the most common South Carolina petroglyphs but arguably the most interesting. Perhaps it is their unknown meaning that makes them so fascinating.

Portable Petroglyphs

This chapter discusses portable petroglyphs other than the portable versions of circle-and-line tar-burner rocks, which are covered in the next chapter. The circle-and-line glyph is distinctly different from any other portable glyphs we recorded. Technically speaking, portable petroglyphs may be so large that they can barely be transported or so small that to inscribe anything on them was quite an accomplishment. Unlike petroglyphs found on permanent rocks, the majority of which were formed by pecking, all the small portable glyphs we observed—except the portable circle-and-line glyphs—were created by incising. With a single exception, all were found in the northwestern Piedmont counties of Anderson, Greenville, Oconee, Pickens, and Spartanburg. Although often quite small and unimpressive, they represent the thoughts and efforts of people. Their relatively small sizes and uncertain origins should not detract from their cultural significance. Four of these carvings were assigned a common site number (38GR320, fig. 51) because they were removed from an unknown location and converted to permanent status by virtue of being mounted in a stone wall that surrounds a cemetery. A fifth carving was also given site status (38GR305, fig. 95) because it was incorporated into a permanent stone barn wall. Because all others were removed from their original locations, they were not given site status; instead they have been assigned identity numbers (figs. 53–60). In some cases photographs of these glyphs are supplemented with drawings to show the carving with greater clarity.

Number One

This petroglyph was found on Glassy Mountain in Greenville County during grading for a road into a new development. It was the first petroglyph reported to us after we advertised in newspapers for information about rock carving. When it was found, only a portion of the glyph was visible because much of the surface was covered with a thin veneer of limonite, which the owner removed to expose the entire carving. The grooves were then cleaned, leaving them a bit lighter in color than the surrounding

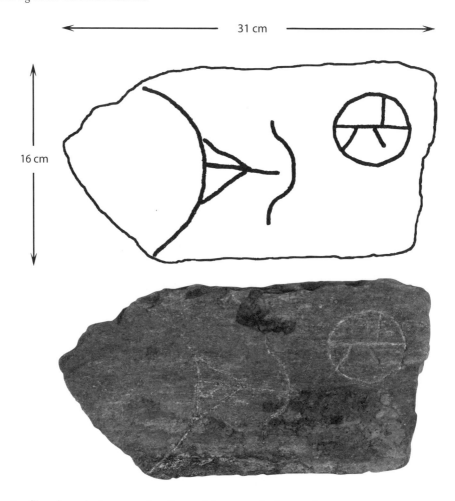

Fig. 53. Sketch and photograph of portable petroglyph number one

matrix (fig. 53). The carvings consist of a small circle dissected by interior lines (a motif somewhat similar to the circle-and-line petroglyph) and several abstract lines.

Number Two

A young girl found this petroglyph while playing in the woods of northern Greenville County. One end of the stone is marred by what appears to be a plow scar (fig. 54). The end where the glyphs are located is stained red, apparently with ocher. All the carvings consist of unidentifiable abstract motifs. The petroglyph was donated to the Pickens County Museum and is on display there.

Number Three

Petroglyph number three (fig. 55), found in Anderson County, is a stone bearing three somewhat triangular-shaped motifs. We recorded several petroglyphs inscribed with similar lines creating simple squares and triangles.

88 CM

18 CM

10 CM THICK

BLACK AREA APPEARS
TO BE PLOW SCAR

Fig. 54. Sketch and photograph of portable petroglyph number two

40 CM

19 CM

12 CM THICK

Fig. 55. Sketch and photograph of portable petroglyph number three

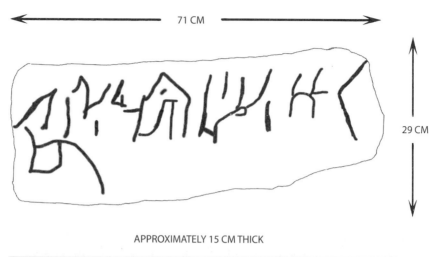

APPROXIMATELY 15 CM THICK

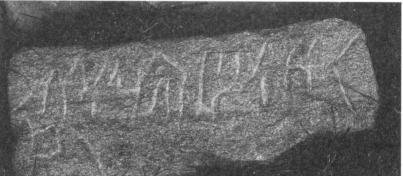

Fig. 56. Sketch and photograph of portable petroglyph number four

Number Four

Found on a farm in southwestern Spartanburg County, this stone (fig. 56) was removed from the field where it was found and is now stored in an old abandoned tenant home on the property. The glyphs consist of a series of well-incised but unidentifiable markings.

Number Five

Shown in figure 57 is one of several elaborately engraved stones found on Lake Jocassee in Pickens County when the lake was being filled after construction. Eroded from the banks by the rising water, this small, engraved stone has glyphs on both sides. One side has a small circle in the center with four panels radiating outward. Inside each panel is an irregularly shaped groove, somewhat similar to a simulated lightning bolt; several unidentifiable motifs are situated near the rock perimeter. The

10.4 cm

Fig. 57. Both sides of portable petroglyph number five

3.43 cm

Fig. 58. Portable petroglyph
number six

engraving on the other side is less complex and features a serpent, a shieldlike figure, and a half circle.

Number Six

This tabular stone (fig. 58) was found in the mountains of Oconee County when a dirt road was being repaired. The stone appears to have been naturally shaped and polished, apparently in a stream, prior to being inscribed. It is one of the smallest

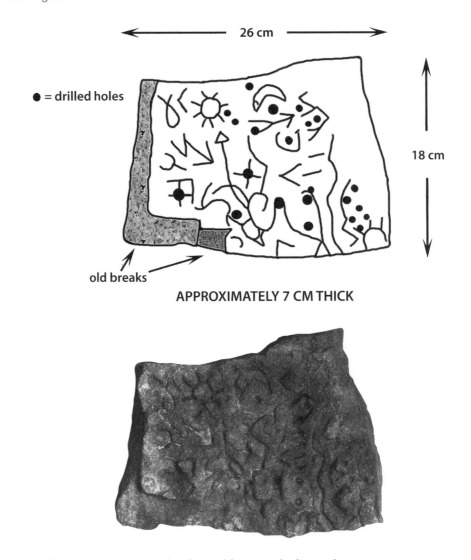

Fig. 59. Sketch and photograph of portable petroglyph number seven

carved stones reported. The incised lines are quite small, and the motif is an un-identifiable abstract form.

Number Seven

A family walking along the shore of Lake Jocassee during the late 1960s found the most elaborately decorated stone recorded by our survey (fig. 59). Wave action was eroding the landform on which this artifact was found. Unlike most of the small portable petroglyphs, this glyph is deeply incised and has small, shallow holes drilled into its surface, apparently by cane, because the bottoms of several have the raised centers typical of holes drilled by hollow canes. Other figures on the stone include

6.3 CM

4.3 CM

Fig. 60. Portable petro-
glyph number eight

a sunlike circle with lines radiating outward, what appears to be a half moon, and several unidentifiable markings. A portion of the carving is missing, and several glyphs may have been truncated. The broken edge is weathered equally with the rest of the rock, indicating a break of some antiquity.

Number Eight

A small gorget is the only example of a rock carving reported from south of the fall line (fig. 60). It was found eroding from the bank of a tidal creek in Charleston County. Broken into two pieces, the gorget was associated with several chipped-stone tool preforms (unfinished tools such as spear and arrow points or knives) and a cluster of burned-limestone chunks that may have been the remains of a prehistoric hearth. Although they are likely rare, there must be similar carvings that have not been reported. The carving shown in figure 60 represents a stylized bird similar to the birdman motif in iconography of the Mississippian period, which began around 1000 C.E. and ended about 1500 C.E. (Birmingham and Eisenberg 2000; Brown

2004 and 2007; Strong 1989). Yet the lack of context for this object prevents us from definitely assigning it to a time period.

The preceding illustrations are not all the small portable glyphs that have been reported for South Carolina. Rather they have been selected to demonstrate the wide range of sizes, motifs, and methods of manufacture that we observed. The carvings represent a considerable range of motifs, from a few simple inscribed lines to elaborately detailed and complex designs. The chronologies of these small petroglyphs remain uncertain, but those shown in figures 57 and 60 appear to be Mississippian.

Circle-and-Line Petroglyphs

Circle-and-line petroglyphs are the only glyphs that exhibit evidence of utility. They are second in number only to the unadorned circle among the glyphs recorded in South Carolina.

Historic and/or Prehistoric?

When I first saw one of these particular petroglyphs, I assumed it was a prehistoric carving. Further investigation showed that similar examples had been recorded in several states, where they are considered to be historic Euro-American petroglyphs (Hockensmith 1986, 100; Swauger 1981) because Europeans who settled along the Appalachian Mountains and nearby are known to have made them. Because rocks bearing these carvings were used on farms for the extraction of pine tar, they are commonly called tar-burner rocks (Bright 1932; Murphy 1969). There is ample evidence that they were also used for leaching lye from the ashes of hardwood (Gould 1948, 108–9; Swauger 1981, 4–6; Hockensmith 1986, 100; Hockensmith 1996; Wiltse 1999, 74–75) and perhaps for other purposes unknown at present.

The Traditional Importance of Pine Tar

Before modern medical practices were widespread, the making and use of medicinal remedies at home was a common practice. Pine tar had a wide range of medicinal uses in both humans and animals as well as nonmedicinal purposes. Humans used pine tar as a salve for poison ivy, blisters, and sores. Pine tar mixed with molasses, honey, or syrup of wild cherry was used as a cough syrup. Drinking water from the surface of tar barrels was considered a good treatment for bronchial coughs and was believed to prevent the recurrence of boils, chronic urinary catarrhs, and other ills. Mixing pine tar with lye soap made a passable shampoo. For animals it was used as a salve on open wounds to prevent infestation by screwworms and other maggots. It was applied to the nostrils of sheep to repel botflies and thus prevent them from laying their eggs there. After cattle were dehorned, a mixture of pine tar and alum was applied to stop the bleeding. Mixed with cottonseed oil, pine tar made an effective

repellent for ticks. It was also used to lubricate wooden wagon axles. Charles D. Hockensmith and Cecil R. Ison present an excellent overview of its many uses in "Kentucky's Historic Pine Tar Industry" (1996).

The Circle-and-Line Motif

Although sharing general characteristics, circle-and-line petroglyphs are as unique as fingerprints, maintaining a common theme yet exhibiting the handiwork of many individuals. Though they are referred to collectively by the same name, there are in fact major distinctions within the circle-and-line classification, including carvings that have an enclosing circle and those that do not (fig. 61). A third, rare variation is a shallow mortarlike depression with a groove carved from the depression to the rock's edge (fig. 62, style 5); the groove drained whatever was being processed in the depression (Hockensmith 1996). The circle-and-line petroglyphs are further divided between those carved on stationary rocks and those carved on small portable stone slabs.

To visualize the typical circle-and-line petroglyph in its simplest form one has only to think of the peace symbol that became so well known during the Vietnam War: a circle whose interior is divided by a centrally located groove with two additional grooves that extend obliquely outward from the central groove. Unlike the peace symbol the circle-and-line glyph's central dividing groove usually extends beyond the circle perimeter outward to the edge of the host rock—and often over the edge and down the face of the rock. In some cases the interior grooves may be absent, may number more than two, or may be randomly placed within the circle. The motif

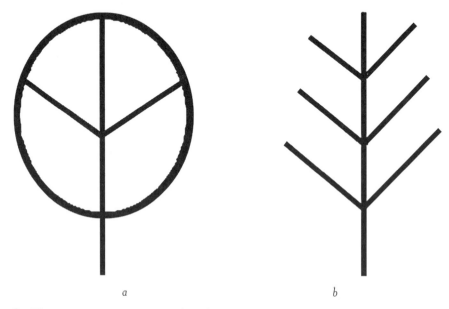

a b

Fig. 61. The two major variations of circle-and-line styles

65

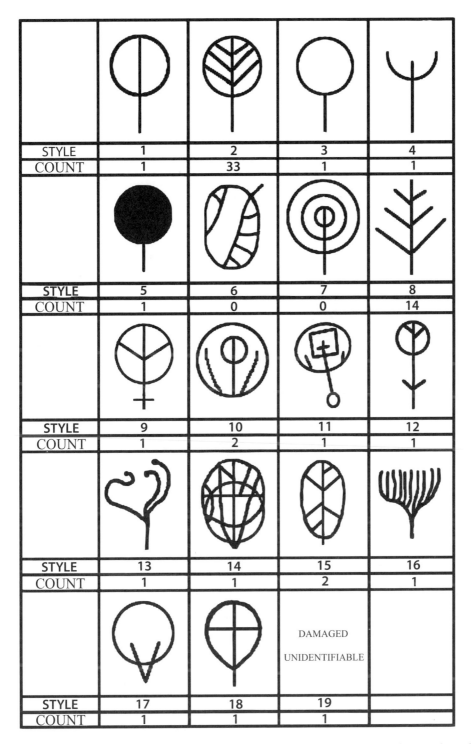

Fig. 62. Styles or variations of circle-and-line petroglyphs. Styles 1–8 were described by Hockensmith (1996, 99–100); styles 9–18 are additional variations recorded in South Carolina. Except for styles 6 and 7, all have been found in South Carolina.

without the enclosing circle closely resembles a stick figure drawing of a tree (fig. 61b). Lacking the circle, it technically fails to meet the criteria for inclusion in the "circle-and-line" category, and the same may be said for those having only a depression and drainage groove, but because historically their function was the same as those carvings with a circle, they are considered variations of the type and are treated as such in the literature. Hockensmith initially defined five styles for the circle-and-line petroglyph (Hockensmith 1986, 124–26); he subsequently added another three to his list (fig. 62, styles 1–8). The South Carolina Rock Art Survey has recorded ten additional styles or variations (fig. 62, styles 9–18). The diversity of shapes and sizes of circle-and-line petroglyphs may reflect their intended uses or simply the whims and abilities of their makers.

Circle-and-Line Petroglyph Attributes

The majority of circle-and-line petroglyphs were created with some kind of pointed tools that were used to peck the designs onto host rocks, but some show evidence of having been created with sharp, straight-edged tools, such as a hatchet, an ax, a chisel, or possibly a stone tool with a sharp, straight edge. Incising made one permanent circle-and-line petroglyph, and two portables had grooves that had been smoothed after they were formed, as if they were deliberately rubbed with an abrasive stone. Some were too eroded to determine their method of manufacture. Two circle-and-line petroglyphs, one portable and one permanent, were altered from their original configurations. Pecking originally created the portable, but at some later date, a chisel was used to carve a second circle and additional grooves over the older ones. The permanent circle-and-line glyph (38SP345) appears originally to have been Hockensmith's style 1 or 2, a small portion of which still remains, but any possible interior grooves have been obliterated because the circle has been carved into a bowl, transforming it into a style 5. The alterations were done with a steel tool; it could not be determined how the earlier version was created.

The portable circle-and-line petroglyphs found in South Carolina are similar in shape and manufacturing techniques to those found on stationary rocks, but the twenty-two portables we were able to measure are somewhat smaller, averaging 32.64 cm lengthwise and 29.68 cm in width, compared to 42.32 cm lengthwise and 40.86 cm width for those on the thirty-seven stationary rocks we measured. These measurements are the circle dimensions only and do not include the drip groove outside the circle, whose length may be determined by the distance from the circle to the edge of the host rock. Measurements for style 4 (no circle) were taken across the glyph's widest dimension and lengthwise only to the point where the last lateral groove intersects with the drip groove. Four portable circles were damaged to an extent that measurements were unobtainable and the total number of glyphs used for calculating dimensions (fifty-nine) reflects their omission (see tables 2 and 3). Portables occurred less frequently than stationary by a count of twenty-six to thirty-eight.

Hockensmith divided Kentucky circle-and-line petroglyphs into three size groups that he called "clusters." Five glyphs range in size between 28 and 32 cm, seven between 40 and 46 cm, and seven between 50 and 53 cm. In Ohio he found that most of a sample of nine clustered between 45 and 50 cm (Hockensmith 1996, 107). He also stated that there is considerable overlap between circle sizes on portable and permanent specimens and gave a size average of between 30 and 46 cm in diameter for the seven portable glyphs and a size average of between 41 and 53 cm for the twenty-four stationary glyphs. In Hockensmith's data the portable circle-and-line petroglyphs he recorded are in general slightly smaller than those he documented on permanent rock. This finding coincides with portable circle-and-line glyphs recorded in South Carolina, which are also smaller than the permanent versions. An absolute comparison of Hockensmith's size data with that compiled by the South Carolina survey was not possible because of the uncertainty of how he arrived at his cluster averages.

Circle-and-Line Distribution

A circle-and-line petroglyph was reported to me in 1983, but fourteen years passed before we began the petroglyph survey and the existence of others became known. It was then I became aware that Stephenson's earlier discovery (Stephenson 1979) was also a circle-and-line motif (fig. 2) although it was not recognized as such in 1979. As additional examples of these boldly pecked petroglyphs were discovered, it became obvious that their distinct and repetitive design set them apart from all the other petroglyphs we were recording. Such a reoccurring theme could not be chance. I soon learned that similar petroglyphs had been documented on the Piedmont and foothills along both sides of the Appalachian Mountains from Alabama to Pennsylvania, but they were found infrequently in the mountains themselves.

Across this huge expanse, only forty-nine of these odd petroglyphs had been recorded, with the majority, twenty-three, being located in Kentucky and twelve in eastern and southeastern Ohio (Hockensmith 1996, 103–5). With so few having been recorded over such a huge area, it seemed likely that the region had not been intensively searched. This hypothesis was validated by the South Carolina Rock Art Survey, which has recorded sixty-four circle-and-line petroglyphs in South Carolina, eight in North Carolina, and two in Georgia. Recent reports (Ashcraft and Hansen, pers. comm. 2003) have added several more to the North Carolina total. Other informants have since extended the range for the circle-and-line petroglyph into New York (Shirley W. Dunn, pers. comm. 1999; Wiltse 1999, 74–75), Missouri (Diaz-Granados, pers. comm. 2003), and Connecticut (Carol A. Hanny, pers. comm. 2004). No numerical count or explicit data are available for these recently reported petroglyphs, but the ones in New York and Connecticut have been referred to as lye-leaching stones rather than tar-burner rocks (Dunn, pers. comm. 1999; Wiltse 1999, 74–75; Hanny, pers. comm. 2004). Because no descriptive data are available they are not included in the databases.

TABLE 2. DATA FOR PERMANENT CIRCLE–AND–LINE PETROGLYPHS

SITE NUMBER	STYLE	WIDTH × LENGTH (IN CM)	CIRCLE	NO CIRCLE	ABRADED CIRCLE	ABRADED, NO CIRCLE	BURNED	CUPULES	REWORKED	RECESSED CIRCLE	DRIP GROOVE ALTERED	NAIL IN GROOVE	NONFUNCTIONAL	HISTORIC	UNDETERMINED	PREHISTORIC	METHOD OF MANUFACTURE UNKNOWN	INCISED	STEEL TOOL	PECKED
38AN227	11	39 × 39	•					•			•		•			•				•
38AN227	10	24 × 23	•								•		•			•				•
38GR205	4	16 × 37		•									•			•				•
Chamblee	8	96 × 110		•			•								•					•
Huff	15	58 × 25	•												•					•
Stone #1	8	40 × 42	•		•										•					•
Stone #2	2	59 × 45		•											•					•
Smith/K	2	43 × 43	•					•							•					•
38GR306	2	24 × 21	•					•							•					•
38GR9	17	26 × 25	•								•		•			•				•
38GR307	2	37 × 35	•												•					•
38GR307	2	20 × 19	•					•					•			•				•
38GR304	2	53 × 51	•							•				•						•
38LU486	8	55 × 30		•		•									•					•
38LU507	2	35 × 34	•		•										•					•
38LU489	2	40 × 44	•								•	•			•					•
38LU489	8	38 × 41		•									•		•					•
38LU490	2	45 × 44	•								•				•					•
38LU487	2	59 × 53	•												•					•
38LU487	2	44 × 46	•								•				•					•
38LU487	13	65 × 71		•				•			•				•					•
38LU488	2	36 × 44	•												•					•
38LU488	8	19 × 15		•									•		•					•
Morgan	2	38 × 39	•		•					3 CM				•				•		
Ball	15	57 × 29	•		•										•					•
38OC378	16	54 × 42		•											•					•
38OC383	18	30 × 28	•												•					•
Moore	8	40 × 25		•											•					•
38PN125	1	75 × 88	•				•								•					•
Burke	2		•												•			•		

SITE NUMBER	STYLE	WIDTH × LENGTH (IN CM)	CIRCLE	NO CIRCLE	ABRADED CIRCLE	ABRADED, NO CIRCLE	BURNED	CUPULES	REWORKED	RECESSED CIRCLE	DRIP GROOVE ALTERED	NAIL IN GROOVE	NONFUNCTIONAL	HISTORIC	UNDETERMINED	PREHISTORIC	METHOD OF MANUFACTURE			
																	UNKNOWN	INCISED	STEEL TOOL	PECKED
38SP335	5	30 × 30		•						•					•		•			
Laney	8	57 × 48		•	•			•								•				•
38SP336	2	33 × 33	•		•										•					•
38SP337	2	36 × 36	•					•						•					•	
38SP13	9	4.25 × 4.25	•								•		•		•			•		
38SP345	2 & 5	52 × 50	•	•					•	•	•				•	•			•	•
38SP366	2	56 × 56	•												•				•	
38YK404	2	80 × 80	•		•										•		•			

TABLE 3. DATA FOR PORTABLE CIRCLE-AND-LINE PETROGLYPHS

COUNTY	STYLE	WIDTH × LENGTH (IN CM)	ROCK TYPE	CIRCLE	NO CIRCLE	ABRADED CIRCLE	ABRADED, NO CIRCLE	ABRADED GROOVE	BURNED	REWORKED	NONFUNCTIONAL	RECESSED CIRCLE	HISTORIC	UNDETERMINED	METHOD OF MANUFACTURE			
															PREHISTORIC	UNDETERMINED	STEEL TOOL	PECKED
Abbeville	2	30 × 27	gneiss	•		•								•				•
Anderson	3	20 × 22	schist	•		•							•					•
Chester	2	33 × 32	steatite	•									•				•	
Greenville	2	26 × 28	gneiss	•				•					•				•	
	8	36 × 28	gneiss		•		•							•				•
	8	38 × 31	gneiss		•									•				•
	12	12 × 12	undetermined	•							•				•			•
	8	28 × 34	undetermined		•		•						•			•		
	2	30 × 31	undetermined	•										•				•
	2	damaged	gneiss	•										•				•
	2	36 × 38	gneiss	•		•								•				•
	2	23 × 26	schist	•				•						•				•
	2	damaged	gneiss	•										•				•
	10	7 × 7	schist	•							•				•	•		
	14	33 × 30	schist	•					•	•				•			•	•
	8	40 × 50	gneiss		•									•				•
	2	damaged	gneiss	•		•								•				•
Laurens	8	45 × 72	gneiss		•									•				•
	2	28 × 28	gneiss	•										•				•
Newberry	2	25 × 25	undetermined	•										•		•		
Oconee	2	36 × 37	gneiss	•		•								•				•
Pickens	8	24 × 36	schist		•									•			•	
Spartanburg	19	damaged	gneiss		•			•	•					•				•
	2	27 × 33	gneiss	•		•								•		•		
	8	42 × 53	schist		•									•				•
	2	34 × 38	gneiss	•										•				•

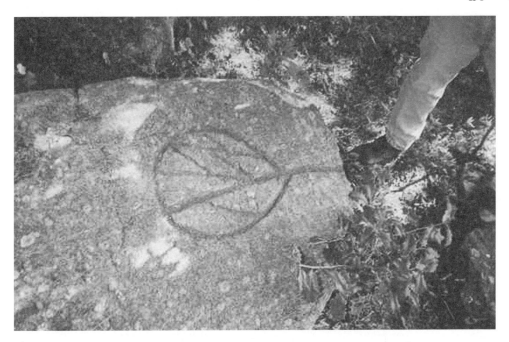

Fig. 63. An example of a circle-and-line petroglyph on permanent rock.
Photograph by Earl Burke

Circle-and-Line Petroglyphs in South Carolina

Permanent Petroglyphs

A majority (59.4 percent) of the thirty-eight circle-and-line petroglyphs recorded
in South Carolina, including the one shown in figure 63, are on stationary rocks.
Thirty-one of these are located near small streams or springs, but one is located high
on a hilltop and some distance from any water source. Six others were removed from
their original locations, having been cut away with jackhammers or dragged away
with tractors, so no determination could be made about their original location or
proximity to water. None was recorded in a rock shelter, as has been the case in
Kentucky (White 1980, 56–57; Weinland and Delorenze 1980, 148; Beck 1982;
Hockensmith 1986, 106–16) and Ohio (Baker 1978).

Unlike the basic unadorned circles that, in South Carolina, are primarily located
on rock domes near mountain crests, circle-and-line petroglyphs have been found
only at much lower elevations in the Piedmont and mountain foothills. When
plotted on a topographical map, the majority of stationary circle-and-line petro-
glyphs are shown to occur along prominent northwest-to-southeast-oriented
ridges that transect Greenville, Laurens, and Spartanburg counties (fig. 64).

Portable Circle-and-Line Petroglyphs

The designs of portable circle-and-line petroglyphs are not unlike those of the per-
manent versions (see fig. 65), but they are impermanent, and—with the exception

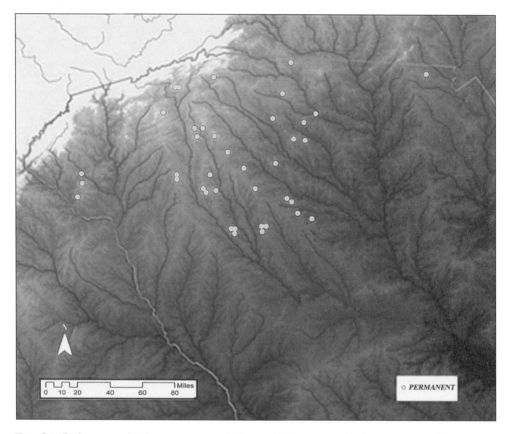

Fig. 64. Ridges on which permanent circle-and-line petroglyphs are most often found. Map by Tamara Wilson

of three—they lack site status. One of the exceptions is a glyph that remains in its original position at site 38LU490 in Laurens County. This petroglyph is situated on a platform made by piling flat rocks on each other to elevate the glyph (fig. 66). This arrangement allowed space for a container to be placed below to catch whatever was processed. The present landowners, descendants of several generations who have owned and lived on this land, say that the petroglyph was in its present location when their great-grandparents acquired the land. They have no knowledge that it (or two others carved on nearby permanent rocks) was ever used.

Two other circle-and-line glyphs were given site status because, although they were removed from their original locations, they achieved a degree of permanency by virtue of being used as grave markers. One (38GR290) is in an African American cemetery in Greenville County (fig. 67). Another (38NE163) is in a European American cemetery in Newberry County; perhaps an indication that race played no role in the creation and use of these glyphs. Both cemeteries date to the early or mid–nineteenth century. Because all but one portable circle-and-line petroglyphs have been removed from their original locations, there is no way to address site data

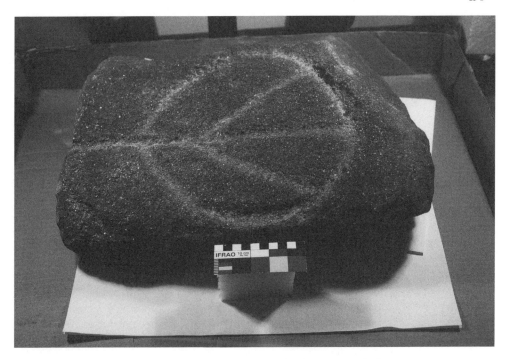

Fig. 65. The first portable circle-and-line petroglyph we recorded in South Carolina (1997)

accurately, and their geographical placement is based on oral information. Nevertheless that data indicate that the northeastern portion of Greenville County is the area of greatest occurrence of these portable petroglyphs. The loss of precise location data is somewhat offset by other data that they do offer. By virtue of several having been incorporated into cemeteries and structures that have relatively well-known chronologies, a time frame for the discontinued use of some of them has been established. Portables accounted for 40.6 percent of the recorded circle-and-line petroglyphs in South Carolina.

Historic Documentation

When the earlier documentation of circle-and-line petroglyphs was done in Kentucky and Ohio, researchers in those states concluded that they were the handiwork of European Americans who migrated into the region from the eastern seaboard. Because circle-and-line petroglyphs were used on farms for extracting pine tar from sap-rich heartwood and from the roots of various species of pine trees, the terms *tar-burner rock* and *tar-kiln rock,* became common names for them. Written and oral sources are well documented for the use of these particular petroglyphs in the processes of pine-tar extraction (Carlton and Ferguson 1977; Hockensmith 1986, 101–2; Hockensmith 1994, 29–32; Virgil Perriman, pers. comm. to Charles D. Hockensmith 1990; Willie Little, pers. comm. to Fred E. Coy Jr. 1975) and lye leaching (Earle

74

Fig. 66. A portable circle-and-line petroglyph on a raised rock platform
at site 38LU490

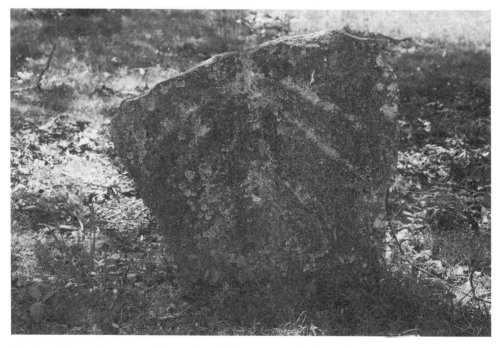

Fig. 67. One of two portable circle-and-line petroglyphs used as gravestones
in mid-nineteenth-century cemeteries (site 38GR290)

1898, 254; Gould 1948, 108–9; Hanny, pers. comm. 2004; Lady and Maslowski 1981, 92; Swauger 1981, 4–6; Wiltse 1999, 74–75). Tangible evidence supporting a historic use for these petroglyphs in Kentucky consists of burned pine-tar residue found on some glyphs that were discovered in rock shelters (Hockensmith and Ison 1996, 8; White 1980, 56–57) as well as the finding that some were carved with steel tools (White 1980, 57). Steel tools were used for creating some of the circle-and-line petroglyphs we recorded in South Carolina. The functionality of circle-and-line petroglyphs for extracting pine tar has also been successfully demonstrated by replicating the process (see figs. 68–70; Hockensmith 1994; Carlton and Ferguson 1977).

The popularity and longevity of the circle-and-line petroglyph for pine-tar extraction probably varied greatly across the region where they have been found. In Kentucky they are said to have been in use as late as the 1940s (Perriman, pers. comm. to Hockensmith 1990), and the practice is thought to have lasted for more than 150 years (Ison and Hockensmith 1995, 37). One bit of information pertaining to the use of a circle-and-line petroglyph was recorded nearby in Georgia. The person on whose property the artifact is located said that his grandmother, who was 102 years old when she died during the 1980s, had lived on the property all of her life. Though she had never known the rock to be used for anything except as a place for burning trash, her father had told her that his father used it as a tar-burner rock. This generational sequence would place its last reported use as a tar-burner rock no later than the mid–nineteenth century. Such a terminal date would be consistent with known instances in which circle-and-line petroglyphs were incorporated into late-eighteenth- and early-nineteenth-century structures in South Carolina—a possible indication of their fall from favor as extraction tools in the upstate.

Using the Petroglyphs to Extract Tar

The Europeans who first settled the backcountry of eastern North America lived in relative isolation. Their access to store-bought goods—and to money with which to purchase them—was quite limited. Among such goods were the much-needed by-products of pine tar. Independent and resourceful people that they were, they customarily made their own. They first had to extract sap from the heartwood of the pine. One of their methods for doing so employed a circle-and-line petroglyph, a tar-burner rock. First sap-rich pine splinters and roots were placed in an old-fashioned iron wash pot (fig. 68), and the pot was then placed upside down on the circle-and-line carving (fig. 69). The interface between pot and rock was sealed with mud or clay to prevent the tar from flowing out of the pot anywhere other than along the groove that would direct it to a container. A fire was then built around the pot. When it was sufficiently hot, the sap became liquefied and flowed along the groove into a container placed below the rock (fig. 70; Hockensmith 1986, 101–2).

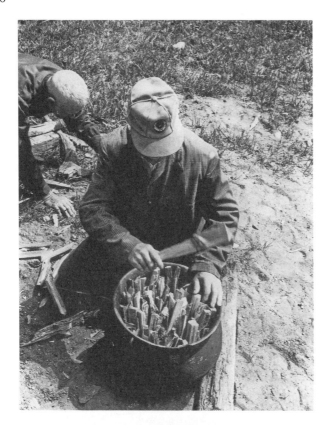

Fig. 68. Placing pine splinters in an iron pot in preparation for extracting sap with the aid of a circle-and-line petroglyph. Photograph courtesy of the Foxfire Fund, Inc.

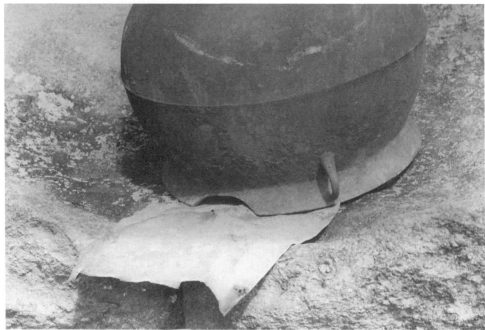

Fig. 69. The pot turned upside down with clay sealing the gap between it and the rock. Photograph courtesy of the Foxfire Fund, Inc.

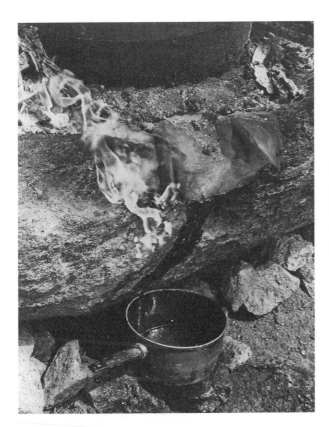

Fig. 70. Liquefied pinesap flowing along the drip groove into a container. Photograph courtesy of the Foxfire Fund, Inc.

Making Lye Water

To make lye, hardwood ashes were placed in a wooden hopper, barrel, or hollowed-out log with a small hole in the bottom. The ashes were then covered with water to leach lye from the ashes. The lye water seeped through the hole and was directed into a container by various methods. A wooden trough often served as a funnel. In other instances circle-and-line petroglyphs were used (fig. 71). The barrel holding the water and ashes was placed on the circle, which captured the lye water and sent it along the drip groove into a container (Mohr 1979, 8, Wiltse 1999, 74–75). The lye water was then mixed with animal fat to produce a strong soap.

Pine tar and lye soap were household commodities produced wherever Europeans settled in eastern North America. Whether the use of the circle-and-line petroglyph in these processes was more or less efficient than other methods is undocumented. Regardless its level of efficiency, however, the evidence finally supports its historic use for extracting pine tar and lye water—and perhaps for other purposes as well.

Testing the Theory

As circle-and-line petroglyphs were recorded in South Carolina, their individual characteristics were noted in detail: their placement on the host rock, the size and shape of the glyph, the configuration of the drip groove (which determined its ability or inability to transport an extracted liquid to a container), and wear patterns

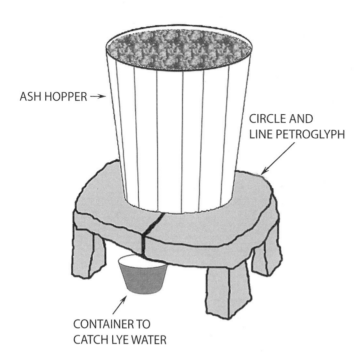

ASH HOPPER →

CIRCLE AND
LINE PETROGLYPH

CONTAINER TO
CATCH LYE WATER

Fig. 71. Leaching lye
from hardwood ashes

created by use. Any circle-and-line glyph that could possibly have functioned as a tar-burner or lye-leaching stone was accepted as such. The majority of those we recorded conform to these historic, utilitarian categories. However, there are others whose attributes or placement eliminate them from consideration as tar-extraction or lye-leaching rocks—or at least make them unlikely candidates—and offer the possibility of their being prehistoric.

The Anomalies

There are some circle-and-line petroglyphs on permanent rocks that—because of their particular configuration, location on the host rock, or size—are impossible, or highly impractical, to use for utilitarian purposes. Two, at site 38SP13 in Spartanburg County and site 38GR307 in Greenville County, were found on nearly vertical rock faces. (One on a vertical rock face has also been reported for Missouri [Diaz-Granados, pers. comm. 2003]). The diameters of the circles in the South Carolina examples are 3 cm for 38SP13 (fig. 72) and 20 cm for 38GR307 (fig. 73), considerably smaller than the average size (44.29 by 39.6 cm) for the permanent circle-and-line petroglyphs as a group, but otherwise they meet all the criteria to be classified as this style of petroglyph. Given their small sizes and near-vertical locations, these two glyphs can obviously not have been used for extraction. The 3 cm glyph is located in a prehistoric steatite quarry; the 20 cm glyph shares a rock with what appears to be a turkey glyph and a bow-and-arrow glyph. These three glyphs are extremely eroded and were discovered when we removed humus from the top of the

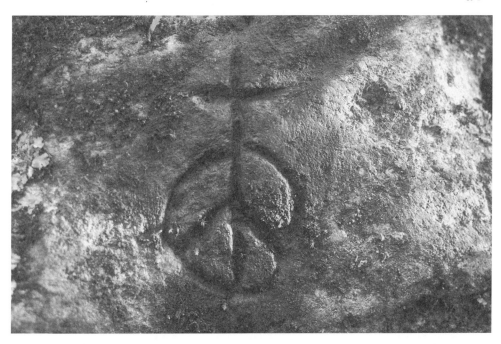

Fig. 72. A 3-cm circle-and-line petroglyph on a vertical rock face at site 38SP13

rock to examine it for possible glyphs. As the humus was swept away, small particles of dirt and dust collected in the shallow grooves of the petroglyphs that were located lower on the side of the rock, making them instantly visible. This cluster of glyphs is several meters distant from a more typical and boldly carved circle-and-line glyph. We found no data that firmly establish a time of origin for any of these carvings. The landowner, an elderly man, had lived on the property all his life and played on these rocks as a boy. We were there because he had reported the more visible carving. He did not know about the almost invisible glyphs until our discovery.

At two sites in Laurens County, 38LU488 and 38LU489, two circle-and-line glyphs occur on the same host rock. At each site one of the glyphs is much more crudely formed and eroded than the other, giving the appearance that one is of greater antiquity than the other. At 38LU488 the glyphs are on a rock not greatly elevated above ground level, rising to a height of only 31 cm at its highest point. The carvings are located on opposing sides and just above the rock's interface with the ground. The crude and eroded glyph could be construed as an aberration of Hock-ensmith's style 4 or 8; the other glyph is a well-made style 2. Because the crude glyph is on a steep face of the rock, it is incapable of holding a pot or loose wood that might otherwise have been placed on it for burning. The well-made style 2 glyph, located on a less steep incline, could probably accommodate a pot or the placement of loose wood (fig. 74a). The drip groove of each glyph terminates just before reaching the ground, and it would have been necessary to excavate holes beneath the rock and to place containers below ground level to capture extracted liquids. As impractical as

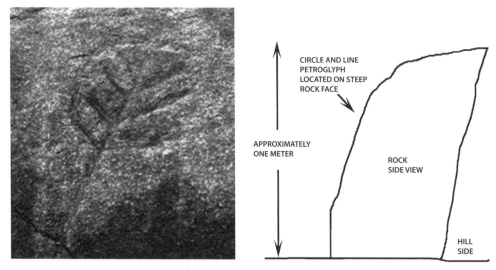

Fig. 73. Photograph (digitally enhanced) and drawing of a 20-cm circle-and-line petroglyph on a near-vertical rock face at site 38GR307

this may seem, because the style 2 glyph could hold a pot or pile of wood, it might have been used for extracting tar or lye water; but the crude glyph on the steep rock face appears to be nonfunctional. There is no evidence of burning, residue, or wear patterns on either glyph. The theory here is that the style 2 glyph is both functional and historic while the crude glyph is almost certainly nonfunctional and could be prehistoric.

The pair of glyphs at 38LU489 is similar to those at 38LU488; one is crudely formed, highly eroded, and somewhat like a hybrid of Hockensmith's styles 4 and 8, while the other is a well-made style 2 in excellent condition (fig. 74b). The crude glyph is situated, like its counterpart at site 38LU489, on a steep slope of the rock with a poorly formed drip groove that terminates well before reaching the edge of the host rock. This drip-groove configuration prevents any possibility of conveying extracted liquids into a container. The well-formed style 2 glyph is located on the flat top of the rock, and the drip groove terminates where it intersects with the rock's vertical face. Of particular interest are two cut nails located in its drip groove. Both nails are broken off even with the bottom of the groove and were likely used to hold in place a container to catch the extracted liquid. It can be assumed that this glyph is functional and historic. The crude glyph is highly eroded and obviously nonfunctional; its purpose remains undetermined. Neither glyph shows evidence of burning, residue, or abrasion from use.

Four circle-and-line petroglyphs were recorded on large flat sheet rocks whose surfaces are very near ground level. Two of these rocks, about twelve meters apart at site 38AN227 in Anderson County, are low and flat enough so that a lawn mower passes over them without touching them (fig. 75). Each glyph is centrally located on

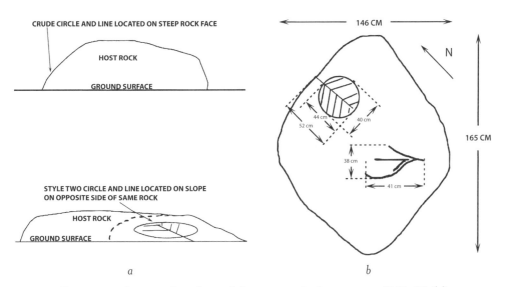

Fig. 74. Drawings of pairs of circle-and-line petroglyphs at sites 38LU488 (*a*) and 38LU489 (*b*)

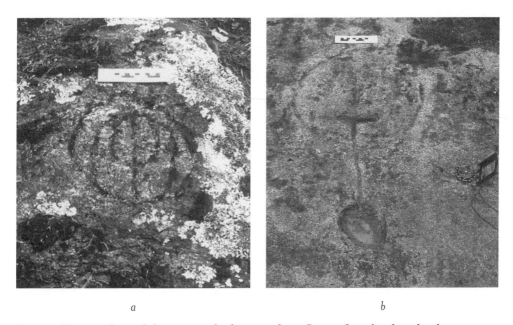

Fig. 75. Two circle-and-line petroglyphs carved on flat surface-level rocks about twelve meters apart at site 38AN227

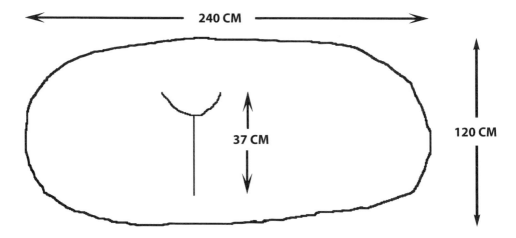

Fig. 76. Drawing of a Hockensmith's style 4 circle-and-line petroglyph at site 38GR205

its host rock, and neither has a drip groove that could have carried an extracted liquid to the edge of the rock. One glyph, a style 10, has a drip groove that does not extend beyond the circle. Eroded to the point of invisibility, this glyph cannot be seen during the day unless it is raining, and it was discovered on such a day (fig. 75a). By virtue of its placement and configuration, this glyph cannot be utilitarian. The second glyph, a style 11, has a drip groove that extends beyond the circle but ends well within the rock's boundaries, where it terminates in a small, shallow cupule (fig. 75b) that is capable of holding approximately two or three ounces of liquid. This second glyph appears to have been created to accomplish a task such as extracting small amounts of dyes or medicinal substances; however, it would be vastly inadequate for capturing needed amounts of pine tar or lye water. Several extremely eroded abstract markings are immediately adjacent to this glyph, and there is no evidence of burning or residual substances on either of the two. The antiquity of the two glyphs cannot be determined, but they are believed to be prehistoric.

A third circle-and-line glyph carved on a ground-level rock, the only style 4 recorded by the survey, stands alone on top of a high hill in Greenville County (38GR205). The glyph has a long drip groove that terminates well before reaching the edge of the host rock; it is the only permanent circle-and-line glyph that is located a considerable distance from water. Its purpose and antiquity are undetermined, but it is has no obvious function and is considered to be prehistoric (fig. 76).

Located at site 38SP336 in Spartanburg County, the fourth circle-and-line petroglyph on a large surface-level sheet rock has a drip groove that docs extend to the edge of the host rock, at which point the rock face drops vertically a distance of 10 cm to a lower level of rock (fig. 77). A historic function for this glyph would not be impossible, but given the limitations on placing any kind of container other than a

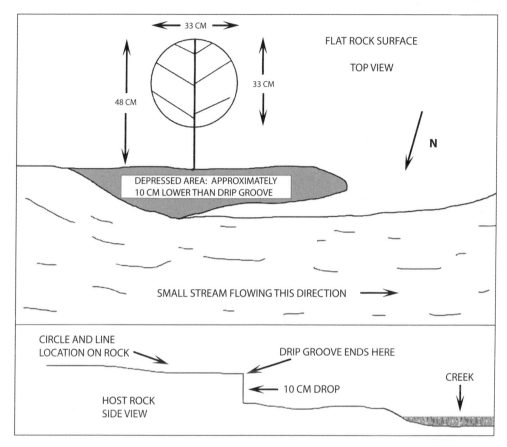

Fig. 77. Drawings of a circle-and line petroglyph located just above creek level at site 38SP336, one of two recorded in similar locations

shallow and flat-faced pan against the vertical rock face, its use for extracting pine tar or lye water appears improbable. There is no evidence of residue, burning, or use wear. The glyph is immediately adjacent to a creek, and when the water rises, the entire rock may be covered. This proximity to water might seem ideal for processing lye, but with such a shallow area in which to place a container to capture the lye water, would it have been feasible?

Perhaps the best example of a nonutilitarian circle-and-line petroglyph is 38GR9, the first glyph documented in South Carolina (Stephenson 1979). This circle-and-line glyph has not one, but two grooves, which begin inside the circle and continue a short distance outside where they join to form a V (figs. 2 and 78). At this point the two grooves terminate, well within the host-rock perimeter, thus eliminating any possibility of this glyph serving to capture and channel liquids into a container. This style 16 glyph is quite weathered and appears to be of some antiquity; it exhibits no evidence of residue, burning, or use wear. Its origin and purpose remain undetermined, but clearly it was not intended to be a tar-burner or lye-leaching rock.

Fig. 78. The "Old Indian" or Spanish direction rock after survey members removed the vegetation that had grown over it (site 38GR9)

A unique form of circle-and-line glyph was recorded in Laurens County at site 38LU487 (fig. 79; plate 10b). The glyph is utilitarian, but its purpose is unclear. Carved on the rounded top edge of a large rock, the glyph is ill suited for holding a pot, which would have been unstable and would have needed some support placed under it to prevent it from tipping over. If clay were used for support and to fill and seal the space between pot and rock, it would have required 10 cm of fill on two sides. If pine-tar extraction was the intent, why not place the glyph on a flatter portion of the rock, of which there is ample space? Below the glyph, the drip groove extends down the vertical face of the rock until it terminates in a small alcove that was carved into the vertical rock face; a container capable of holding several ounces of extracted liquid would fit in this alcove. It appears that any liquid directed into the alcove would have been poured or dripped onto the carving above, but if the substance to be collected were already a liquid, why not put it directly into the container? However, if the liquid had to be extracted from some solid substance, perhaps it was pressed or pounded on the upper glyph, whose grooves would then direct the extracted liquid into the alcove below. This scenario seems more likely. This circle-and-line glyph is one of three with a small alcove or depression carved into the rock at the end of its drip groove, one other being located no more than fifty meters distant from this one. The glyph shows no evidence of firing or tar residue. Whether it is of prehistoric or historic origin could not be determined. Rocks suitable for creating more typical circle-and-line glyphs are abundant nearby.

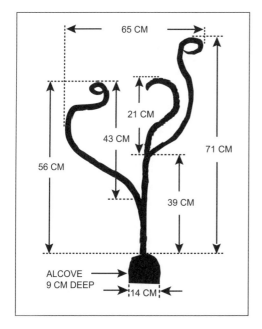
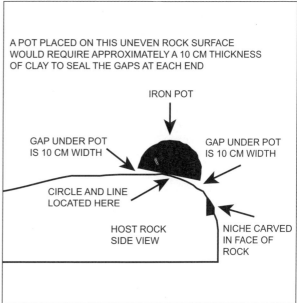

Fig. 79. Sketches of an eccentric circle-and-line petroglyph with small alcove carved into rock at the end of its rip groove (site 38LU487)

Although a minority, these nonconforming circle-and-line petroglyphs may represent a link between a prehistoric origin and an historic adaptation. Since they exhibit the attributes of documented historic circle-and-line petroglyphs, these oddities must be factored into any judgments concerning their purposes and origins.

Heat Damage

In order for pine tar to be extracted, the sap has to be heated enough to convert it into a free-flowing liquid. Hockensmith reported the results of two experiments that he conducted. He first used a very hot fire with poor results. The fire cracked the clay sealing the pot and rock interface and exposed the pinewood to the intense heat. Stopping the experiment about one hour and fifty minutes after building this fire, he had a yield of about one quart of pine tar diluted with water. When he removed the pot, he found that the stone had cracked and much additional tar water had seeped into the cracks, and when he attempted to move the stone, it fell apart. For his second experiment, Hockensmith used a smaller fire over a longer period. The tar flowed in a larger stream than during the first experiment and was a much denser liquid. He was unable to determine the quantity of tar extracted because he had a sixteen-ounce can under the slab, and once the can was full the rest of the tar could not be collected. After this stone cooled, he attempt to move it, and although no cracks were visible, it broke into several pieces just as the first rock had done. Hockensmith speculates that one reason for the scarcity of portables may be that they did

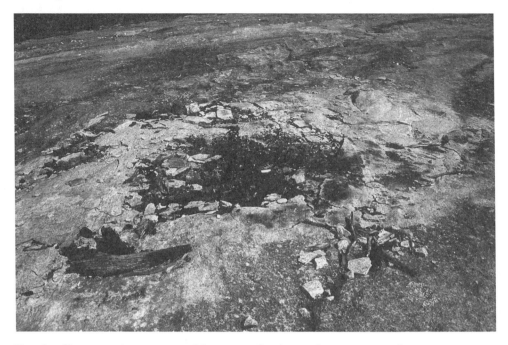

Fig. 80. Extensive damage caused by a campfire burned on gneiss rock

not survive their first firing. He also says the reason most circle-and-line petro-glyphs in Kentucky are found on large permanent rocks may be because they are less susceptible to heat damage (Hockensmith 1994, 33, 36). Only five glyphs recorded in South Carolina showed possible disfiguration or discoloration from firing. Two portables were fractured, but a cause could not be determined. Another had soot on the circle interior but none outside; the rock itself was not damaged. A permanent tar-burner rock, and the largest circle-and-line petroglyph that we recorded, had abundant evidence of burning and possible tar residue; it was not fractured. One other permanent circle-and-line petroglyph was blackened from burning but there was no damage to the rock. In comparison rock surfaces where campfires are built are routinely damaged (fig. 80). Perhaps the relative absence of breakage or discol-oration argues against excessive or repetitive use of fire on most of the circle-and-line petroglyphs recorded in South Carolina, or this lack might be attributable to the use of gneiss, granite, and schist rocks, which are harder than the sandstone rocks that Hockensmith used in his experiments. Regardless of the explanation, rock frac-turing does not appear to have been a problem for South Carolina's circle-and-line petroglyphs, and unless this can be attributed to the different types of rock, it may indicate that they had uses other than tar extraction.

The Drip Groove

The configuration of the drip groove in circle-and-line petroglyphs was paramount in transporting tar or lye water into a container. Regardless of all other attributes,

if the drip groove cannot accomplish this task, then do we have a tar-burner or lye-leaching rock? We did not methodically test the drip grooves on the circle-and-line petroglyphs that we recorded to determine their ability to accomplish this task, but we did pour differing volumes of water on some to observe flow patterns. In most instances the water spread beyond the drip groove and over the face of the host rock. When we tried this test with portables, the water ran back under the rock before flowing downward into a catch pot in an uncontrolled manner. In only one instance was as much as 50 percent of the water captured—and only after we placed a wide pan well back under the rock to capture the unevenly distributed water. Pine tar, being much thicker than water, might not react in the same manner, but what about lye water?

Surface Abrasion

The majority of circle-and-line petroglyphs recorded in South Carolina were too eroded to determine if their working surfaces had been altered by use abrasion, but we were able to identify sixteen (25 percent) that had obvious abrasion patterns confirming their use for purposes other than pine-tar or lye extraction. A stone that was used for extracting grape juice offers one possible alternative. The grape press consisted of a flat stone slab with a deep groove carved just within the rock's perimeter (fig. 81). As the grapes were pressed, the groove directed the extracted juice into

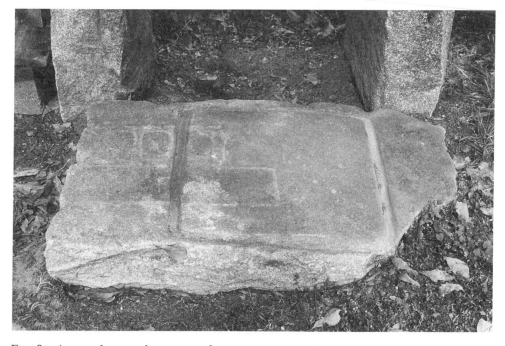

Fig. 81. A carved stone that was used to extract grape juice

a container via a small spout carved in one corner. This press was used as recently as the mid–twentieth century (David Phillips, pers. comm. 1997). Although this carving is not a classic circle-and-line petroglyph, its use of grooves carved into a stone slab to process a substance and direct the extracted liquid into a container is essentially the same. Abrasions were documented on glyphs with circles (styles 2, 3, and 15) and those without enclosing circles (style 8). The abrasions occur within and sometimes extend outside the glyphs' parameters. Six (9.38 percent) of the sixteen abraded glyphs we identified are portables with circles; two (3.13 percent) are portables without circles. Six (9.38 percent) are permanent with circles, and two (3.13 percent) are permanent with no circles. Some are highly smoothed, obviously the result of a considerable amount of rubbing; others are roughly abraded and pitted, apparently a result of pounding yet-unidentified substances. Hockensmith mentions that in Kentucky the circle interior on one glyph was abraded in order to form a level surface (Hockensmith 1986, 109). This practice was observed on two permanent circle-and-line petroglyphs in South Carolina, but the others exhibiting abrasions showed no evidence of an attempt to level the rock surface; rather their abrasions were caused by some kind of use. Use wear on these petroglyphs does not preclude their use for pine-tar extraction or lye leaching, but it does confirm their having been used for other purposes as well, raising another, yet-unanswered question of their function and origin.

Cupules

Seven (11 percent) of the circle-and-line petroglyphs have associated cupules. In four instances the cupules are located on the same rock as the glyph; at three sites, they are on adjacent rocks. One has four cupules within the glyph itself, two of which are dissected by the grooves. It could not be determined if the grooves or cupules were created first or what purpose the cupules may have served. No cultural affiliation with the circle-and-line glyphs can be argued for the other cupules.

Abandonment

Europeans did not populate the region where circle-and-line glyphs are found in South Carolina to any great extent until the late eighteenth century. No doubt some Europeans did make circle-and-line petroglyphs, perhaps for use in different extraction processes, but their use, after an initial flourish, appears to have fallen from favor rather quickly. Evidence supporting this probability is the recording of six circle-and-line glyphs—five portable and one permanent—that were incorporated into early historic structures, some of which are known to date to the late eighteenth century. One carving was recovered from a stone fence that was constructed in the very early nineteenth century. Two served as foundation supports beneath a home constructed in the late 1700s (plate 10b). A fourth was removed from a stone chimney, the only remnant of an old house whose age is unknown but obviously of considerable antiquity. A fifth portable was discovered being used as a step into an old

outbuilding on a farm that was established in 1835. When the farm was sold in 1900, the new owners recognized the odd carving, and they and their descendants, have kept it on the property since that time. Another, considered a permanent type because of its large size and weight, was discovered being used as a hearthstone in front of a fireplace of an old home. The carving was face down on the bottom of the stone and its presence unknown until recently, when the home was torn down and the chimney rocks were salvaged. Two portables were used as gravestones in mid-nineteenth-century cemeteries. Rock is abundant in the area where these glyphs occur, and their use for construction purposes was not out of necessity. Rather it seems more logical that these carved rocks were used for building because they were inefficient at accomplishing the tasks for which they had been created. Whatever the reason, these glyphs were being abandoned soon after their use began. We found no defendable data or oral history supporting their manufacture or use as extraction tools beyond the mid–nineteenth century.

A Prehistoric Presence

Since I first learned that the circle-and-line petroglyphs were tar-burner rocks, I have wondered why anyone ever thought their use as such might be a good idea. Somehow, however, the tar-burner rock caught on, and its use spread along the Appalachians and the adjacent areas.

As our South Carolina survey discovered an ever-increasing number of circle-and-line petroglyphs, a few exhibited attributes that raised questions about their intended function as well as their historic origin. These anomalies shared the circle-and-line theme, but their sizes, configuration, and/or placement on host rocks exempted them from consideration as tar-extraction or lye-leaching tools, in some instances rendering them totally nonutilitarian. Although few in number, these nonconforming examples prompted me to again consider the possibility that at least some of these carvings might predate the arrival of Europeans. My interest then focused not on their well-documented historic uses but on the motif itself. If the motif did exist in prehistory, have examples survived to support this possibility? With a long and established tradition of pine-tar extraction without the use of so-called tar-burner rocks, what initiated their use in the process? There can be only three possibilities: settlers in the New World brought the concept with them from Europe; immigrants invented the method, apparently not long after European settlement began in the Appalachian region; or—what I believe is the most plausible explanation—Native Americans created circle-and-line petroglyphs for as yet unknown purposes of their own, and then European settlers copied the motifs for use in their various extraction processes.

The Old World Connection

A brief look at the history of pine-tar extraction in the Old World makes the use of the circle-and-line petroglyph for this purpose appear unfeasible. Archaeological

and historic records have firmly established that the methodology for pine-tar extraction was mastered long before Europeans arrived in the New World and that it did not involve the use of tar-burner rocks. Archaeologist have discovered an Etruscan shipwreck with naval stores dating to 600 B.C.E. (Blount 1992). The Gauls of the maritime region of France were producing naval stores in 407 C.E., and in the centuries following tar and pitch were produced in various European and Asian countries. Thus it is clear that tar and pitch were being extracted and that their by-products were used in Europe and other parts of the world long before discovery of the New World. (The term *naval stores* originally referred to pine-tar-based products used in the maintenance of pre-twentieth-century wooden ships, which were caulked and waterproofed using pitch, or tar, derived from various species of pine. The term now applies to all products derived from pinesap, among them paint, varnish, soap, lubricants, linoleum, and roofing materials.)

The ancient Greek scientist and philosopher Theophrastus (circa 372–287 B.C.E.), provided a detailed description of the tar kiln, or tarkel, used in the production of tar in Macedonia and Syria (Butler 1998, 3–4). The kilns he described were basically the same as tar kilns used in North America as late as the 1950s. Varying in size, these kilns were of simple but efficient construction. The ground was cleaned of debris and either tamped hard or covered with clay to form a hard surface to prevent the extracted pine tar from seeping into the ground. Sap-rich pine was then stacked on this surface and covered with soil; a hole was formed in the top so the wood could be ignited and the airflow controlled, allowing the wood to smolder but not flame, thus melting the pinesap rather than igniting it. A pipe or trench in the kiln floor directed the liquefied sap into a container that was placed outside the kiln and just below ground level. This long-established extraction method was brought to the New World by European settlers, and it was instrumental in the production of naval-stores products, which became an important industry along the eastern seaboard of North America shortly after settlement began.

A motif carved onto stone that is remarkably similar to the North American circle and line is rather common in Western Europe. Called a "cup and ring," this petroglyph design consists of a circle or concentric circles with a groove that extends from the interior often to the edge of the host rock (fig. 82). As a rule the European examples are more artfully rendered than the North American circle-and-line petroglyphs, and they are commonly associated with cupules, which is uncommon for the North American circle-and-line petroglyphs. European cup-and-ring petroglyphs date to the Bronze Age (3500–2000 B.C.E., Hobson 2006), thus predating the earliest records for pine-tar extraction. No evidence has been found to support a utilitarian use for the European glyphs. If the tar-burner rock had existed in Europe, then logically the technology should have accompanied migrants to the New World. If this were true, it seems reasonable that evidence of their use could be found wherever suitable rock was available, but the existing data do not support such

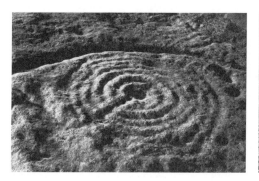 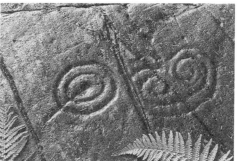

Fig. 82. Two examples of cup-and-ring petroglyphs in the British Isles.
Courtesy of Ian Hobson, British Rock Art Collection (BRAC)

a scenario. Rather the circle-and-line petroglyph appears to have come into use in the Appalachian and adjacent Piedmont, reached its zenith, and declined without spreading much beyond this region. Without any supporting evidence, it is reasonable to eliminate the Old World as the origin of the tar-burner or lye-leaching rock.

Independent Invention?

As European immigrants to the New World moved westward from the eastern seaboard in the eighteenth century, large commercial tar kilns were already well established along much of the eastern and southeastern coastal plain. It is likely, however, that even in this area of intense commercial production, there were people who acquired pine tar for their personal use by extracting it themselves. Those people who subsequently moved into the Appalachian region carried with them an understanding of traditional extraction methods. That fact is emphasized in an article by James A. Hall (Hall 1933), first published in John William Baker's *History of Hart County* in the Georgia Piedmont region in 1933, but written earlier. According to Hall:

> Our grandfathers performed many kinds of work which are almost forgotten now. One of these was "running" tar, and the tar kiln was a familiar object throughout the country. This tar was made from small split sticks of rich heart pine. These sticks were stacked in a slanting position in a kiln, which usually consisted of a small excavation in the side of a hill or embankment. The bottom of this excavation was hammered smooth and hard so that the hot tar would flow towards the outlet and spill itself into a vessel placed below the mouth of the opening outside which was slightly below the level of the kiln floor. When the wood was all stacked in order, it was covered with green pine brush, except a small opening at the top. At this spot the wood was lighted and the entire heap covered with soil in such a manner as to prevent a blaze. As the fire progressed downward among the pine sticks, the hot resin ran down them to the hard floor of the kiln and thus found its way into the vessel awaiting it at the outlet.

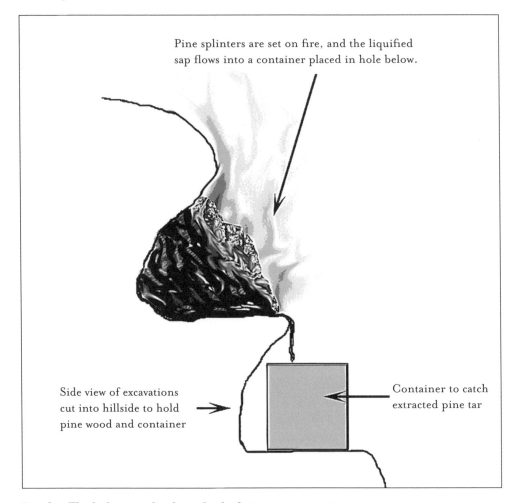

Pine splinters are set on fire, and the liquified sap flows into a container placed in hole below.

Side view of excavations cut into hillside to hold pine wood and container

Container to catch extracted pine tar

Fig. 83. The hole-in-a-bank method of pine-tar extraction

The tar-extraction method Hall describes (fig. 83) is somewhat similar to the large-scale commercial kilns along the eastern seaboard: the pinewood itself was set on fire and then partially smothered by covering it to control the rate of burning. Although Hall does not mention use of circle-and-line petroglyphs for tar extraction, it is still possible that they could have been used at that time and in that area of Georgia. Hall's article does indicate, however, that the more traditional methods had not fallen from favor. Given the long-standing use and success of traditional tar extraction methods, how likely is it that someone decided a circle-and-line carved on a rock might be a better way to extract pine tar? It is not impossible, but it is highly improbable.

The Native American

There are quite a few examples of prehistoric rock art that are similar, arguably identical, to the historic circle-and-line petroglyph. If circle-and-line petroglyphs as we

Fig. 84. For their circle-and-line petroglyphs, European settlers may have copied Native American carvings such as this one at Track Rock Gap in Georgia.

know them, or something vaguely similar to them, already existed when Europeans settled the Appalachian region, then their incorporation into various extraction processes did not require a huge stretch of the imagination. If native peoples were observed using similar rocks to extract nut oils, dyes, or medicinal substances from plants and roots—or if Europeans saw just the motifs—then perhaps an inquisitive observer might have wondered how it would work as a tar-burner rock. It is my belief that this or some similar scenario gave rise to the tar-burner rock.

Prehistoric Similarities

Examples of Native American petroglyphs remarkably like the historic circle-and-line glyphs recorded in our survey are found in North and South America. The similarities are too great to dismiss them arbitrarily as coincidental. An example near our survey area may be seen at a well-known prehistoric petroglyph site—Track Rock Gap—in Union County, Georgia. Dr. Matthew Stephenson, director of the U.S. Branch Mint in Dahlonega, Georgia, visited the site and gave the first written account of the glyphs in 1834. A wide array of petroglyphs are carved on a series of steatite boulders. Among the carvings are several circles with dissecting lines that are quite similar to the circle-and-line motif. One of these is identical in manner to Hockensmith's style I (fig. 84).

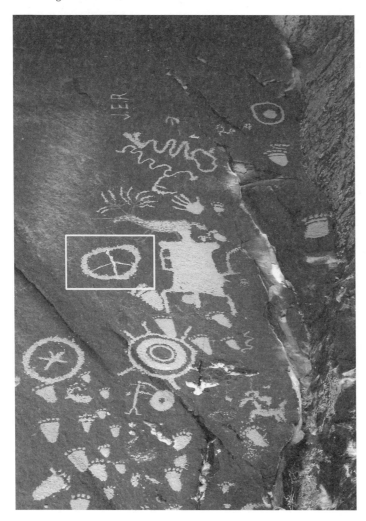

Fig. 85. A motif
(in white rectangle)
at Newspaper Rock,
Utah, similar to a
modern peace symbol
or a tar-burner
petroglygh

A glyph similar to the modern "peace symbol" is seen at Newspaper Rock in southeastern Utah (fig. 85), and many boldly pecked examples of circles with dividing lines that extend beyond the circle to the edge of the host rock have been recorded in northern Arizona and southern Utah. Their purpose is unknown, and speculation about their use varies, but most locals refer to them as "waterglyphs" (fig. 86) because they believe them to be prehistoric direction markers that point the way to water (Allen 2004; Ford et al. 2004, 29; Cody Spendlove, pers. comm. 2005). If these glyphs were found in eastern North America, they would be categorized as Hockensmith's style I tar-burner rocks.

Hockensmith's style 8 is also a rather common motif at prehistoric rock-art sites, and examples can be found on various rock-art Web sites, particularly those showing rock art of the California and Nevada desert regions. Photographs and drawings of similar motifs are found in various publications as well, and one identical form has been noted in Pennsylvania. Paul Nevin calls these motifs "stick-figure trees"

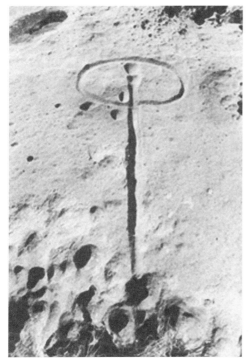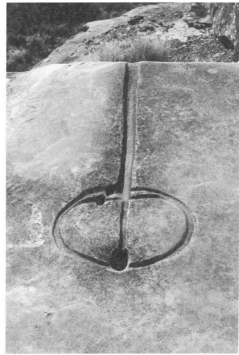

Fig. 86. Examples of prehistoric "waterglyphs" found in northern Arizona and southern Utah. Photographs courtesy of Utah Rock Art Research Association

(Nevin 2004, 240), indicating that he found more than one (see fig. 87a). Carol Diaz-Granados and James R. Duncan have recorded another example from eastern North America, "The World Tree," carved on a Spiro shell cup (Diaz-Granados and Duncan 2004, 212). Robert F. Heizer and Martin A. Baumhoff recorded similar examples in Nevada and eastern California (Heizer and Baumhoff 1962). Garrick Mallery found examples at Tule River, California (fig. 87b), and at Owens Valley, California (Mallery 1972, 1:55, 57).

Similar motifs are drawn on an old Ojibwa birch-bark scroll as pictographs illustrating a song. One is interpreted as "The Big Tree in the Middle of the Earth"; a tree motif next to a bear means "it stands that which I am going"; and one coupled with the figure of a person means "I stand by the Tree" (Mallery 1972, 1:240, 242, 244). Examples of these treelike motifs (fig. 87) and circles dissected by lines are too numerous to mention, but they range widely across the prehistoric North American landscape. Similar motifs are found in Colombia and Mexico as well (fig. 88).

If historic circle-and-line petroglyphs have roots in prehistory, then what was their original purpose? Perhaps these petroglyphs were part of a Native American belief system involving ceremonial preparation of substances such as medicines or body paint, or they may have been no more than tools used to extract oil from nuts,

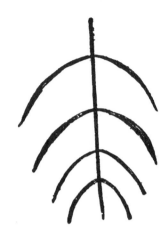

a *b*

Fig. 87. Examples of treelike petroglyphs: (*a*) on the Susquehanna River in Penn-sylvania and (*b*) at Tule River in California. These motifs are similar to Hocken-smith's circle-and-line style 8.

an explanation proposed by Barbara R. Duncan, education director at the Museum of the Cherokee Indian, in Cherokee, North Carolina. Sharon Littlejohn, general administrator at the museum and an expert on traditional Native American cooking, agreed with Duncan's assessment. (These opinions were expressed in a 2005 letter from Duncan to Conway Henderson, discoverer of a circle-and-line petroglyph in Spartanburg County.) Any of these extraction processes could easily account for the variety of abrasions found on some circle-and-line glyphs. Because some are obviously nonutilitarian, the motif may also have significance totally apart from physical function—perhaps serving some spiritual purpose. We may never know the reasons for these prehistoric circle-and-line petroglyphs, but their existence across much of the North American landscape presents a strong argument for their having been the stimulus for the creation of the historic circle-and-line petroglyph by early European settlers.

Summary

The South Carolina Rock Art Survey recorded a total of sixty-four circle-and-line petroglyphs in ten counties. Thirty-eight are situated on permanent rocks, and twenty-six are portable. Of the permanent glyphs, twelve were recorded in Laurens County, eleven in Greenville County, eight in Spartanburg County, three in Oconee County, two in Anderson County, and one each in Pickens and York counties. The twenty-eight that were in their original locations were assigned site numbers. Ten of the permanent circle and-line petroglyphs were not given site numbers; nine had been removed from their original locations, and for one, in Spartanburg County, the landowner sent us a general location and a photograph, but we were unable to

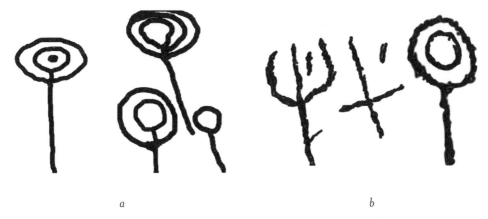

a *b*

Fig. 88. Petroglyphs found in (*a*) Colombia, South America, and (*b*) Nuevo Leon, Mexico, both similar to North American circle-and-line motifs

visit the site to get more precise data. Seven permanent glyphs have attributes that firmly establish them as being historic. Seven—because of their location on the host rocks and because their size or configuration render them useless for any known historic extraction processes—allow speculation that they could be prehistoric. Twenty-four had no identifiers to suggest their placement in either category, but because they are typical of most of those in other states that have been identified as historic extraction tools, it seems reasonable to assume that these twenty-four might also be of historic origin and use. Those considered to be unquestionably historic are all style 2. Those seven that might be considered prehistoric are in seven different styles, and the twenty-four glyphs of undetermined dates consist of eleven style 2, six style 8, two style 15, and one each of styles 1, 5, 13, 16, and 18.

Twenty-six portable circle-and-line petroglyphs were recorded: fourteen in Greenville County, four in Spartanburg County, two in Laurens County, and one each in Abbeville, Anderson, Chester, Newberry, Oconee, and Pickens counties. Because they were being used as gravestones in cemeteries, two portables were given site status (38GR290 and 38NE163). Four glyphs had attributes that unequivocally identified them as historic. Two small examples are presumed to be prehistoric, and no determination could be made for the other twenty. The historic glyphs consist of two style 2, and one each of styles 1 and 3. The prehistoric glyphs are styles 10 and 12. The undetermined glyphs consist of twelve style 2, six style 8, and one each of styles 14 and 19. An additional eight circle-and-line glyphs were recorded in North Carolina. Four are on stationary rock, and four are on portable rocks. All are style 2. Two permanent circle-and-line petroglyphs, a style 2 and a style 8, were recorded just across the state line in Georgia. The data acquired from out-of-state glyphs were not used in compiling statistics for South Carolina's circle-and-line petroglyphs.

Historic Euro-American use of the circle-and-line petroglyph in various extraction processes apparently stemmed from attempts to create a more efficient (or novel)

method for extracting pine tar or leaching lye than those settlers brought from Europe. Although the stimulus for this historic innovation remains uncertain, similar prehistoric petroglyphs are found in both North and South America. If these preexisting Native American petroglyphs did serve as the model for tar-burner rocks, no documentation has been found to support that possibility; yet it is difficult to imagine that they had no influence in the extraction processes used by European settlers. How the historic circle-and-line petroglyph came to be used in extraction processes, or the origins of the motif itself, was probably irrelevant to those who used it for tar burning or lye leaching and ultimately expanded its range along the Appalachian Mountains. Its historic use—once established and without any records to the contrary—pretty much assured that it would be identified as Euro-American in origin.

The popularity and longevity of the circle-and-line petroglyph for pine-tar extraction probably varied greatly across the region where these glyphs have been found. In Kentucky they are said to have been in use as late as the 1940s (Perriman, pers. comm. to Hockensmith 1990), and the practice is thought to have lasted for more than 150 years (Ison and Hockensmith 1995, 37). No absolute chronology for their use in South Carolina has been established, but based on the incorporation of such rocks into early structures and on the total lack of written or oral history about them, they appear to have been used for a much shorter time than in Kentucky. The reason for their decline is as unclear as their origin, but it may be attributed to any number of factors. Perhaps they simply proved less efficient than expected, or perhaps commercial tar-based products became more readily available on the frontier. The origins of the circle-and-line petroglyph and all their uses may never be determined, but it is an interesting bit of Americana—historic and perhaps prehistoric—that serves as yet another testimony to mankind's imagination and ingenuity, his willingness to improvise and adapt to meet immediate needs.

The point of this chapter is not to challenge the findings of some very accomplished researchers. They have proven a historic identity and use for the circle-and-line petroglyph. I, on the other hand, have not proven a prehistoric one. I simply point out that archaeologists have the privilege, indeed an obligation, to question and explore beyond that which seems obvious.

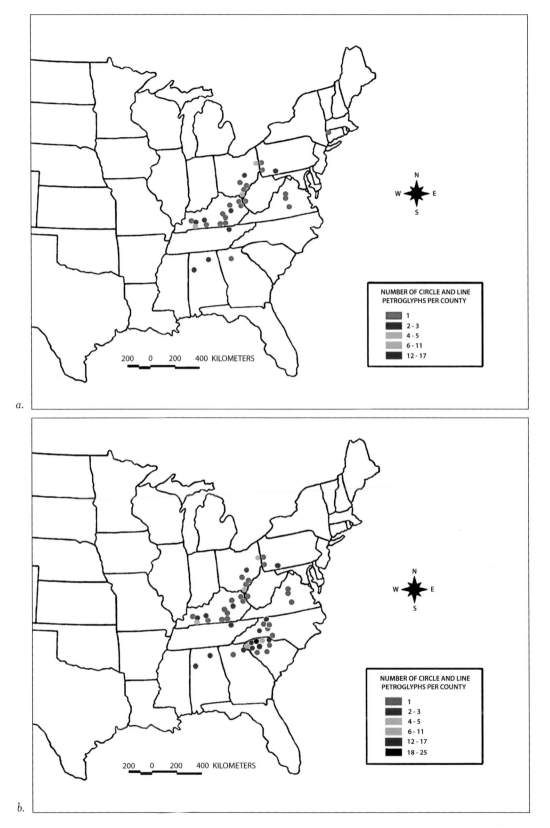

Plate 9. Distribution of circle-and-line petroglyphs prior to the South Carolina
Rock Art Survey (*a*) and after completion of the survey (*b*)

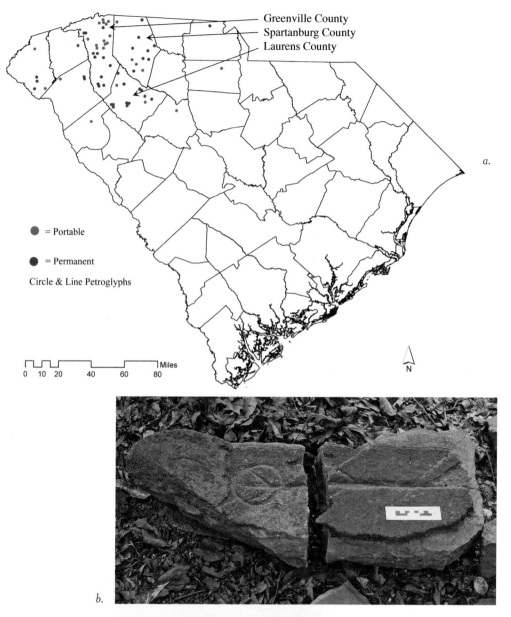

= Portable

= Permanent

Circle & Line Petroglyphs

Plate 10. Circle-and-line petroglyph locations in South Carolina (*a*); a circle-and-line petroglyph used as foundation stone (*b*) at a house constructed during the late eighteenth century in Greenville County; an oddly formed circle-and-line petroglyph (*c*) discovered at site 38LU487 in Laurens County

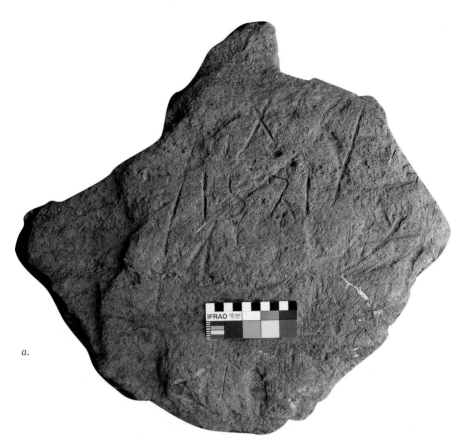

a.

Plate II. A stone somewhat similar to the Pardo stone, found in the same vicinity and inscribed with the date 1571 (*a*), and the Fort Prince George stone (*b*), recovered in 1967 during archaeological excavations conducted at Fort Prince George (site 38PN1) in Pickens County. Below the boldly inscribed date "1761" are the faint initials "H.S." and the year "1770."

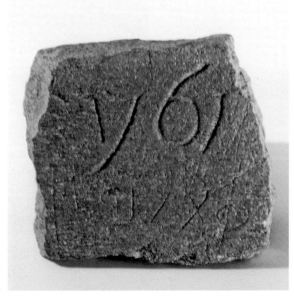

b.

a.

Plate 12. A photograph of the only
pictograph discovered near mountain
crests, before (*a*) and after (*c*) enhance-
ment using a computer-graphics program;
the pictograph is located at site 38PN102
in Pickens County on the vertical rear
wall of a rock shelter (*b*).

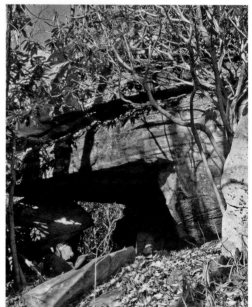

b.

c.

a.

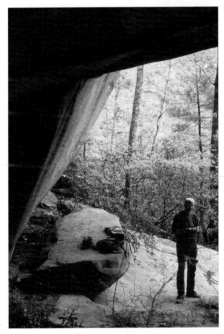

b.

Plate 13. Dr. Cato Holler at site 38PN134 in the foothills of Pickens County (*b*), a rock shelter that is host to eight catlike figures drawn with dark rust-red ocher. Prehistoric pottery and chipped stone were recovered from the shelter floor. Located on the inclining rear wall, the drawings are visible (*a*), but those near the bottom are faded more than those near the top. The figures are arranged in facing pairs with two so small that they are difficult to see. When the pictographs are computer enhanced (*c*), two small figures (in white rectangles) are somewhat visible, but the figure on the extreme lower right is still nearly invisible.

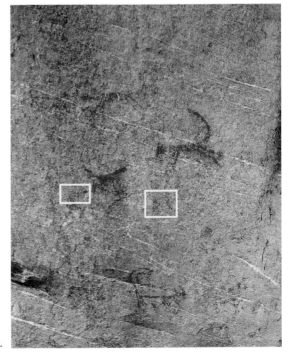

c.

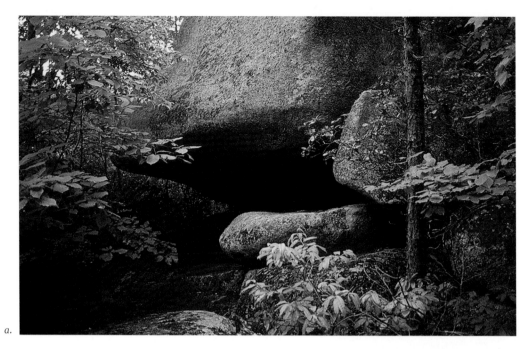

a.

Plate 14. Site 38KE281, a rock shelter in Kershaw County (*a*), which has pictographs spanning much of the ceiling. Tommy Charles taking a series of photographs of the ceiling of the shelter (*b*) in an attempt to capture images invisible to the naked eye. Photograph *b* by Brian Johnson

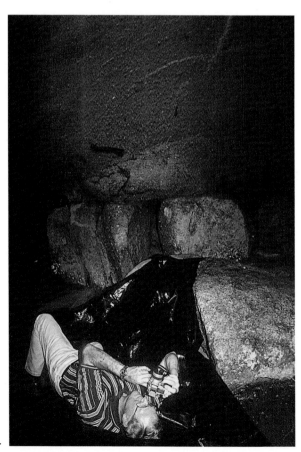

b.

a.

Plate 15. An unenhanced photograph (*a*) of part of the ceiling at the Kershaw County shelter (site 38KE281) and the same segment after computer enhancement (*b*)

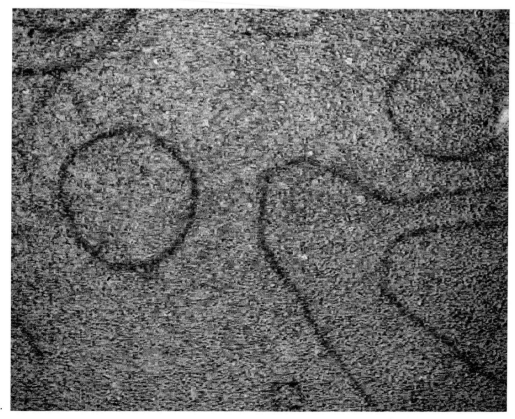

b.

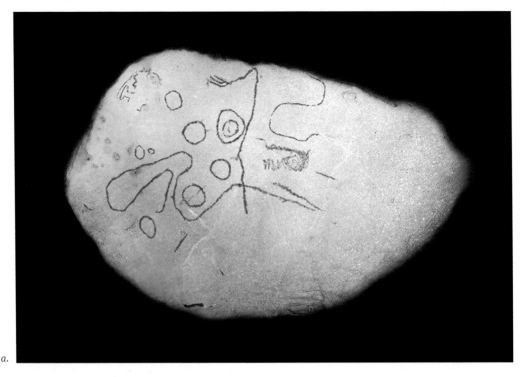

a.

Plate 16. Brian Johnson, inside the shelter at site 38KE281 in Kershaw County (*b*), enhanced and joined individual photographs to create the final image of the entire ceiling (*a*).

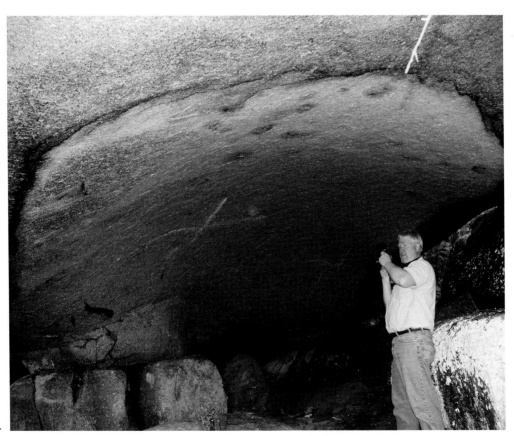

b.

Historic-Period Rock Art

The things we understand are rarely as intriguing as those that we do not, so it is not surprising that for many people historic-period rock art lacks the appeal of its prehistoric counterpart and thus has not inspired an equal research interest. In the American West and perhaps in the eastern states as well, native peoples continued to create rock art long after the arrival of Europeans. We know this because there are many examples of horses, guns, and other motifs revealing their association with, or observations of, these newcomers. It is also likely that Native Americans continued to use motifs similar to those they created in prehistory.

A Point of View

Postcontact rock art should not be considered less important than the images carved prior to the arrival of Europeans. Like its prehistoric counterpart, historic rock art is widespread across and limited to South Carolina's Piedmont and Blue Ridge Mountains. Within those regions it may be found wherever rock is available and people have tended to spend leisure time. It may share the same rocks as prehistoric works or stand alone. The carving of petroglyphs appears to have been more prevalent prior to World War II, and its decline may be attributable to a host of economic and cultural factors that changed rapidly after the onset of war. On the other hand, pictographs, now called "graffiti," have flourished, possibly because of the availability of cheap spray paint that is easily and quickly applied. With the possible exception of the petroglyph shown in figure 95 and plate 4b, no evidence has been found that native South Carolinians are responsible for creating rock art that postdates the arrival of Europeans, and relatively few examples of historic period rock art have been found coexisting with that believed to be prehistoric (table 1).

Historic rock art is often found in the vicinity of early-twentieth-century textile mills. To understand why this is so, one has to understand the economic factors that dictated living conditions in mill communities during that period. There were few automobiles and no television; very few people owned radios or telephones. Air conditioning and central heat were unavailable, and the majority of people still cooked

on wood- or oil-burning stoves. Summers were hot, and so were the houses; often the coolest place to be was outdoors.

Most of the early textile plants along the eastern seaboard utilized water as a source of power; water either directly powered the mill machinery or was used in boilers that created steam to run the machinery. Therefore many mills were located in the Piedmont, where swift-flowing streams are far more abundant than on the lowlands of the coastal plain. Many mills were constructed at places where rapids naturally occurred, and dams were constructed to create reliable water supplies for the mills. Having limited transportation and little surplus cash to spend on entertainment, mill employees spent considerable time during the hot summers near these rapids and dams, where they could picnic, swim, fish, and perhaps stay a bit cooler. They also found time to carve and paint on the abundant rock found at these locations.

By the mid–twentieth century, the economy was changing. The mill owners were selling the houses in their mill villages to individual owners; automobiles were common. Workers were becoming more affluent and more diversified in their employment, and the textile industry in the Southeast eased into a decline that continues to this day. Most of the mills are now closed, and many have been torn down, their now much-in-demand and expensive bricks and timbers sold for salvage. Many homes occupied by the mill workers have been abandoned and have fallen into disrepair, but some were purchased by individuals who have renovated portions of the villages, quaint reminders of a way of life now gone. No longer do the locals regularly congregate at the dams and rapids, and finding rock art of more recent vintage at these locations is uncommon.

Perhaps rock-art artists of more modern times did not demonstrate as diverse a range of motifs as their prehistoric counterparts, but they did express themselves, carving human images (figs. 89 and 94–96), skulls and crossbones (fig. 90), animal figures (fig. 91), and religious symbols and verses (figs. 92 and 93). Carving of names, initials and dates (figs. 97, 99, and 100, plate 11) was common, and on occasion petroglyphs were also painted, creating a composite petroglyph/pictograph (figs. 89, 91, and 92). Occasionally rock art was subjected to alterations at some later date (fig. 98). The photographs in this chapter show a sample of South Carolina's historic rock art.

The Works of Modern-Day Rock Artists

The Face at Site 38SP330

A three-dimensional human face is carved on the sharp vertical spine of a rock that projects slightly over and just above the Pacolet River in Spartanburg County (fig. 89). Traces of a bluish-white paint remain, a reminder that the face was once painted. The name "Robert L. Webb" and the date "October 5, 1939" are carved on top of the rock. Local legend is that Webb carved the face, but it is uncertain if this tale is true or if it the attribution took root because the name and date are close to the

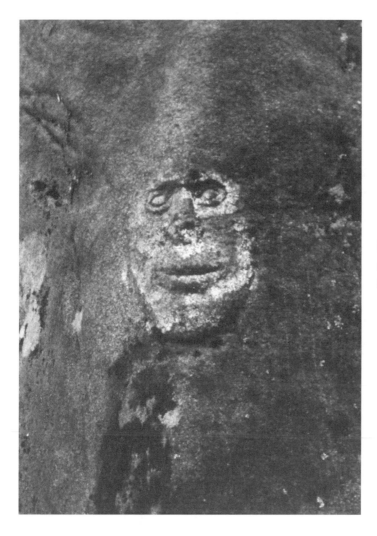

Fig. 89. The three-dimensional human face at site 38SP330

face. There are also other initials and carvings on the rock, including one abstract carving that may be prehistoric.

The Skull and Crossbones at Site 38SP331

The skull and crossbones were a favorite subject for mill-village glyph carvers (and painters), including the carver who created the image at site 38SP331 in Spartanburg County (fig. 90). An interesting bit of ingenuity is seen in this and some similar creations. The dams at the mills were often constructed with stone quarried on the spot. The quarrying left drill holes scattered over the rock, and these were frequently incorporated into a glyph carver's artwork as ready-made facial features. Some of the skulls were painted while others were left natural. A few have been defaced with more-modern spray paint.

102

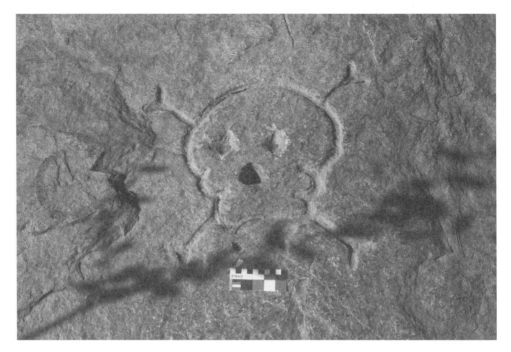

Fig. 90. Skull and crossbones at site 38SP331. The nose is a previously created drill hole.

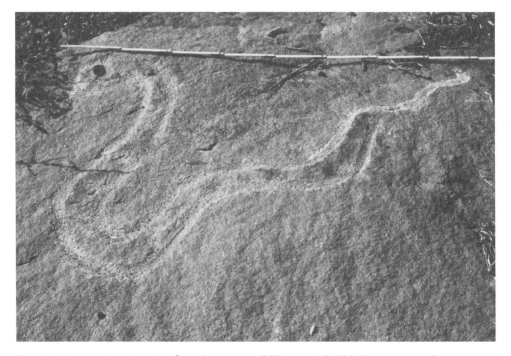

Fig. 91. Engraved and painted snake at site 38SP331. A drill hole serves as the eye.

The Snake at Site 38SP331

The single zoomorphic motif found at the same historic site as the skull and cross-bones is a snake, which is almost two meters in length and would be considerably longer if it were "stretched out." After the outline was pecked into the rock, the interior was painted blue and the grooves white (fig. 91). The snake's eye is a quarry drill hole.

The White Cross and Dot at Site 38SP331

The northern part of the South Carolina Piedmont is known as the "Bible Belt," and religious verses and symbols are commonly found on just about any surface suitable for painting. Many were carved in stone as well. At the same site in Spartanburg County as the skull and snake are a cross and dot carved into a large boulder overlooking the Pacolet River and painted white (fig. 92). It is unclear what the white dot might symbolize.

The Petroglyphs of Clemson Turner

Clemson Turner was a mountain man raised in Mountain Rest, Oconee County, South Carolina. Beginning in the late 1930s and through most of the 1940s, he carved religious verses on rocks, primarily along the Chattooga River, which serves as a portion of the boundary between South Carolina and Georgia (fig. 93). By day he worked as a loom fixer in a textile plant. Late in the day he would go down to the Chattooga and carve by lantern light as darkness approached. Turner was an artist as well as a carver of religious verses, and he had the ability to see potential subjects in natural rock forms. One example is his "Indian Head" petroglyph (fig. 94). The rock has a series of natural parallel lines to which Turner added a face, creating a Native American wearing a western-style bonnet (Mickel Turner [son of Clemson], pers. comm. 2006). Several descendants of Clemson Turner have continued his tradition and have since added their names beside his original carvings. Because we were unable to get a GPS reading at the location of these carvings, or to pinpoint their exact location on a topographical map, we have not given them site numbers.

The Little Man at Site 38GR305

By virtue of its motif, this small petroglyph is the only one lacking initials or numbers that is known to be of historic origin. The glyph depicts a person, presumably a male because of its hat and what appears to be a long-barreled gun or long tube-like pipe on his left (fig. 95). The lower portion of the carving is somewhat obscured, and all the details could not be defined. There is an interesting tale about the supposed origin of this petroglyph. The carving was discovered during the 1920s, when a tract of land was cleared and plowed on Hopkins Plantation near the present-day community of Fork Shoals in southern Greenville County. The plantation was acquired by the Hopkins shortly after the Cherokee ceded that portion of their land to the State of South Carolina. The land has been handed down to successive

Fig. 92. Cross-and-dot
petroglyph, painted white,
at site 38SP331

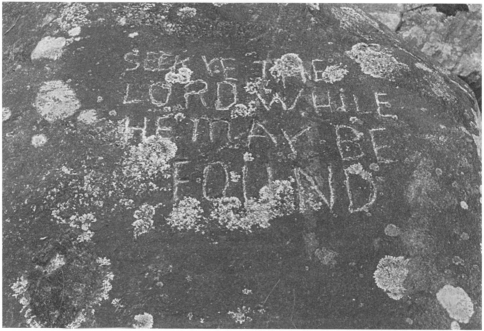

Fig. 93. Verse from Isaiah 55:6 carved by Clemson Turner on a rock beside
the Chattooga River. Photograph by Mickel Turner

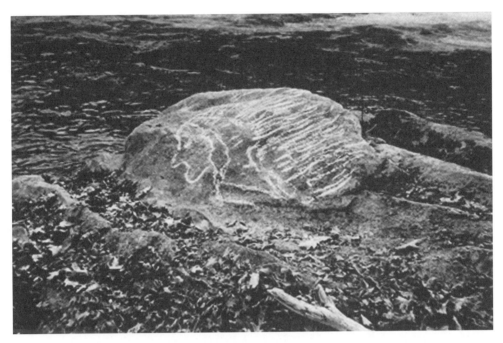

Fig. 94. Clemson Turner's "Indian Head" on a rock near the Chattooga River

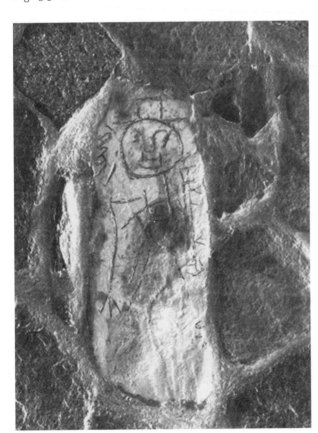

Fig. 95. The little man at site
38GR305 (digitally enhanced)

generations of Hopkinses, and their descendants live there to this day. The present owner said that allegedly, when the Cherokee still owned a portion of the northwest corner of South Carolina, there was a trading post near where the carved stone was found; supposedly the Cherokee would come there to trade. That assertion remains unverified, but it has allowed speculation about the origin of this artifact to run rampant. Does the carving represent a European male as viewed and carved by a Native American who came to the trading post, or is it a Native American, with a hat and gun acquired by trading there? The stone has been placed in the interior stone wall of a barn to protect it from the weather and possible theft. Because it is now in a permanent location, it was given a site designation.

The "Big People" at Site 38FA306

When told that I was conducting a search for rock art, a collector of Native American artifacts in Fairfield County replied, "I'll go find you some." He proceeded to search his own extensive tract of land, which has an abundance of large boulders. A few days later I received an excited call in which he reported a carving of a man "ten feet tall" and a woman only slightly smaller. My first thought was that he had seen a natural rock formation suggestive of human forms (a common report), but when I went to the site, there were the "Big People" he had reported. They are the largest individual petroglyphs recorded during our survey (fig. 96). The carvings appear

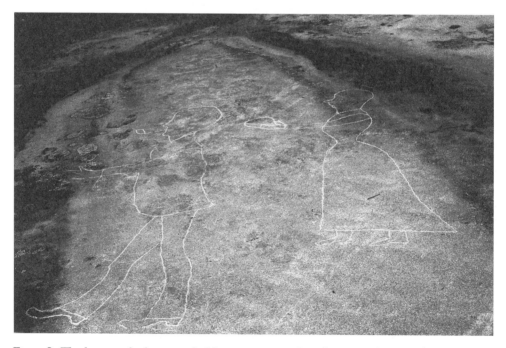

Fig. 96. The largest glyphs recorded by our survey, found at site 38FA306. The man measures almost ten feet, and woman is about eight feet.

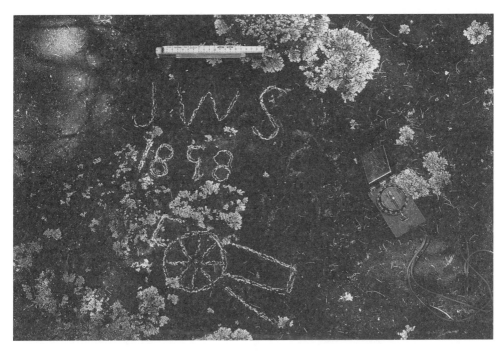

Fig. 97. A cannon with a date and initials at site 38SP338

to be incised, but because they are highly eroded it is difficult to be sure. The two people are beautifully formed and were crafted by an artistically talented person with a keen eye for human proportion. Their clothing styles date to the early to mid–nineteenth century, but these glyphs could have been created at a later date.

How they were discovered is also interesting. When exploring his property for rock art, the owner parked his ATV right on top of this carving, but because the sun was overhead, he could not see them. He continued on foot, and after hours of futile searching, he walked back to his vehicle near sunset. By then the low angle of the light skimming across the rock made the previously invisible glyphs easy to view. Had he parked his ATV in another location, these glyphs might never have been discovered.

J.W.S.'s Cannon at Site 38SP338

A local landowner in Spartanburg County took our volunteers to see a petroglyph and to inspect nearby rocks where he thought other petroglyphs might exist. Located on a flat sheet rock beside a small branch, a small petroglyph consisting of the initials "J.W.S.," the date "1898" and a representation of a cannon is so faintly incised that had the landowner, who already knew its location, not pointed it out, our crew likely would not have found it. After trying unsuccessfully to use reflected sunlight to better define the petroglyph for taking a decent photograph, we resorted to tracing the glyph with soft chalk (fig. 97). We used the reflected-sunlight procedure

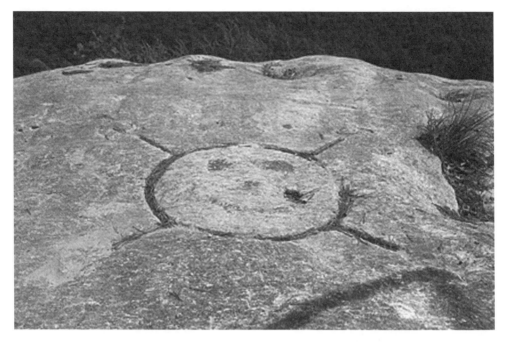

Fig. 98. Historic petroglyph later altered by the addition of a smiley face

to examine the remainder of the large rock but found no additional petroglyphs on it. Other grooves that had piqued the informant's interest proved to be natural.

The Smiley Face

This glyph is actually in Georgia. The circle has four lines and the letters indicating the points of the compass. This portion of the glyph is obviously of some antiquity. At a later date, someone added the smiley face within the circle (fig. 98).

Initials and Dates

The most common historic petroglyphs consist of initials and numbers, or combinations thereof, most of which were made by incising rather than by pecking. Even when illiteracy was common, most people were likely able to carve numbers and their initials.

Names, initials, and dates that were carved well back in the nineteenth century are rather common, and—assuming that the dates are accurate—they serve as chronological markers (fig. 99). The oldest date that we recorded on a permanent rock was in Laurens County at site 38LU422. The date is partially obliterated. The numerals one, seven, and nine are fairly distinct, but the last digit has suffered some form of damage and is no longer discernable (fig. 100). This site has both historic petroglyphs and some that are believed to be prehistoric. All the glyphs that are identifiable as being historic are visible by day, but those considered prehistoric are so eroded

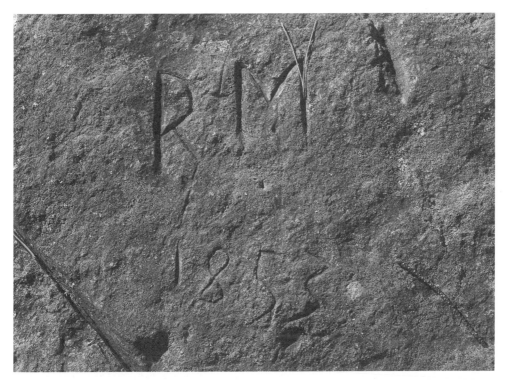

Fig. 99. Initials and date (1853) at site 38SP347

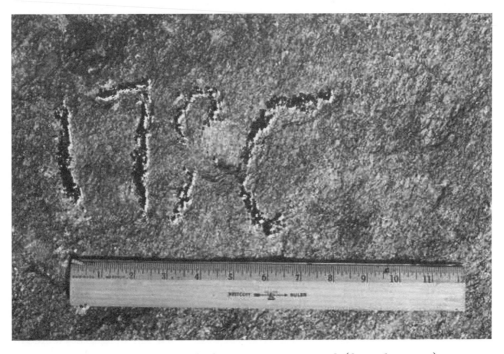

Fig. 100. The oldest dated petroglyph on a permanent rock (from the 1790s)
that we recorded during our survey, at site 38LU422 (digitally enhanced)

that they can be located and viewed only just before the sun sets or at night enhanced with lights.

The Earliest Postcontact Petroglyphs.

There are several other examples of dated postcontact rock art that vie for recognition as the earliest so far found in South Carolina. Taken at face value, the oldest would be the "Pardo stone" (fig. 3), which has the date "1567" incised into its surface. Treated as an interesting curiously since it was found in 1934, this small stone was never recorded as a petroglyph. In recent years another small portable petroglyph was supposedly found in the same general area as the Pardo Stone. There is no documentation of who found this second stone or exactly where it was discovered; this stone has "1571" inscribed on it (plate 11a). The problem with accepting either of these artifacts as South Carolina's earliest historic petroglyph is the lack of proof of their authenticity. It is entirely possible that they were created in much more recent times than their inscribed dates imply. Also there is no assurance that they were created in the area where they were found. They might have been transported there from other locales.

Our survey discovered a postcontact-period petroglyph site, obviously of considerable antiquity, while exploring near the crest of Tomassee Knob Mountain in Oconee County. Having found only a few historic initials, our group decided to discontinue the search and sat on several large boulders to eat lunch before beginning the journey back down the mountain. Then one of the volunteers, Michael Bramlett, remarked that he could feel faint grooves in the rock on which he was sitting (plate 4a). A close visual inspection failed to reveal evidence of petroglyphs, but—suspecting that the rock did indeed have carvings invisible to the eye—we made a second trip to the site with a sheet of black plastic, lights, and talc powder. Covering the rock with the plastic and using lights to sidelight the rock (plate 4b), we could make out faint markings, but they were still too vague to define their forms. Attempts to photograph them produced equally poor results, and we resorted to covering the rock with a thin coat of talc powder (plate 5a). After we brushed away the excess powder, we discovered crude, imperfectly formed, and randomly placed "alphabet-like" petroglyphs (plate 5b). There are no identifying names and no indications (such as periods) that the letters might be initials; nor are there any numbers or dates. The physical deterioration of these carvings—which were made on a very solid rock—indicate they are of some antiquity, and it is conceivable they could date to the early postcontact period. At the base of Tomassee Knob there was a Cherokee town known as Tamasee (also spelled *Tomasee* and *Tomassee*), which still housed remnant Cherokee populations as late as 1776, when Colonial Andrew Williamson and his South Carolina Militia destroyed the town. This fact allows for interesting speculation about the creation of these particular petroglyphs. They could be mindless doodles created by anyone lingering on the mountain or the handiwork of a semiliterate settler who was incapable of accurately writing the alphabet or spelling recognizable words. Another

possibility is that someone from the Cherokee village below had observed European writing and was attempting to emulate those markings. Given the overlap of Cherokee and European cultures in this area during the early postcontact period, attributing the petroglyphs' origin to one source or the other cannot be defended. Without evidence to confirm that the glyphs were created early in the postcontact period, we can only speculate that they may be among South Carolina's oldest postcontact petroglyphs.

The earliest authenticated postcontact petroglyph was discovered at the site of Fort Prince George in Pickens County. Located on the Keowee River, the fort was constructed in 1753 and abandoned by 1768. A team of archaeologists from the University of South Carolina, assisted by volunteers, excavated the site (38PN1) during 1967–68; just before it was submerged in Lake Keowee, which was created by construction of the Keowee Dam by Duke Power. While excavating a rock-filled cellar, the team found a small rock bearing the date "1761" and below it, faintly incised, what appear to be the initials "H.S." and the date "1770" (plate 11b). By virtue of this stone having been buried during the life of the fort and excavated and recorded by archaeologists, it has a valid claim to be the oldest documented historic–period petroglyph recorded in South Carolina.

Regardless of its relatively recent origins and the lack of mystique that antiquity generates, rock art of the historic period is an important continuum of the human expression. Its cultural value should not be overlooked because of its relative newness, nor should it be relegated to a lower status than works created in prehistoric times. Perhaps when it has acquired greater antiquity, rock art of recent vintage will be viewed and studied with the same fervor with which we now examine prehistoric works.

Prehistoric Pictographs

Those familiar with the climate of the southeastern Unites States are well aware that the environment is unkind to exposed surfaces. If prehistoric pictographs ever existed on exposed rock surfaces in South Carolina, as surely they must have, they have not been reported and were probably long ago destroyed by forces of nature. Only three pictographs believed to be prehistoric have been discovered in South Carolina. Two are located in Pickens County, and the third is located approximately 110 to 120 miles southeast in the sand hills of Kershaw County near the fall line. Their continued existence may well be attributed to their locations inside rock shelters that afford uncommon protection from the elements. Because these shelters are dry and relatively dark, no lichen or mosses, which might have destroyed the drawings, grow within these recesses. Another shared attribute of these particular shelters is that their interior rock surfaces show no evidence of exfoliating, a condition that we observed in most of the shelters that we investigated and that perhaps contributes to an explanation of why so few South Carolina pictographs now exist. However, the fact that we recorded three pictograph sites among the relatively few rock shelters that we investigated, gives reason for optimism that others may yet be found.

The Pictograph at Site 38PN102

More than a century after James Mooney's initial report of a pictograph in northern Greenville County in 1891, Andrew Carroll, a geology student at Furman University, found a pictograph in the late fall of 1999 while conducting a geological field study in the general area of Mooney's discovery.

Created with yellow-orange ocher, Carroll's discovery includes a circle with seven evenly spaced outward radiating lines. Near the end of each line a figure is drawn (plate 12a). The lower portion of the pictograph is more weathered than that nearer the shelter ceiling, so the figures located nearer the ceiling are more visible. Three figures are discernible to the naked eye. One is a quadruped with antlers, probably representing a deer or an elk. Another appears birdlike and is somewhat similar to the thunderbird symbol more commonly found in the western and the

north-central United States. A third figure appears to be a fish or some aquatic animal. After digital enhancement of less-visible figures to allow a clearer view of their forms (plate 12c), one appears to be an arrow (or perhaps a stylized human), and another has a treelike form. Two figures were so faded and smudged that we were unable to do more than confirm their presence. Carroll's discovery is just inside the Pickens County line. It cannot be argued that Carroll's find is the same as Mooney's, but considering the isolation of the area where the two counties join, it is possible that Mooney may have guessed incorrectly at which county he was in. At an elevation of approximately two thousand feet, site 38PN102 is the highest pictograph site we recorded.

The Pictograph at Site 38PN134

In the early spring of 2003, another Pickens County pictograph site was discovered. Dr. Cato Holler Jr., a dentist whose hobby is the study of insects living in caves and rock shelters, found the site on one of his excursions. On the vertical rear wall of a large west-facing shelter are eight figures drawn with reddish-brown ocher (plate 13a). Seven of the figures could represent almost any animals with long tails, including cats, foxes, dogs, or squirrels. One other motif is located relatively low on the wall, and even when digitally enhanced, it is too eroded to identify its intended form with certainty. Two other figures are so small and faded that they are difficult to see with the naked eye, but digital enhancement of the photographs, make them quite easy to observe (plate 13c).

Water dripping from the edge of the shelter roof is eroding a small portion of the earthen floor, and prehistoric pottery and thermally altered chipped stone was found in this eroded area. Indisputable association for these artifacts and the pictographs cannot be made, but evidence for historic use of the shelter is totally absent. Because ocher is inorganic, it was impossible to date these drawings through radio-carbon dating, but they are believed to be prehistoric.

The Pictograph at Site 38KE281

When surveying nearby archaeological sites, I had visited the Kershaw County rock shelter that is now site 38KE281 on several occasions without discovering its pictographs. This particular shelter always gave the impression that it must have been a prime prehistoric habitat (plate 14). A few small prehistoric pottery sherds had been observed inside, and although the shelter was previously inspected for rock art, none had been found.

The discovery of a pictograph on the shelter ceiling was sheer luck. I told Dr. Holler about this shelter so that he might include it in his research on cave-dwelling insects. Because the shelter is located in an extremely isolated area, it is unlikely that anyone could find it without a guide, so I asked Frank and Andee Steen, who know the area intimately, to take Dr. Holler to the shelter. Frank and Andee, their son Van, and several members of the Holler family trekked into the site on a snowy

winter day. The snow on the ground apparently reflected the daylight in a way that made the pictographs faintly visible. Van made a sketch of what he thought he could see on the ceiling, and sent it to me. I returned to the site to photograph the drawings, but the snow was now gone, and the drawings were again invisible. Artificial light only washed out any possible markings. Using various kinds of film—black and white, infrared, color print, and color slide—with combinations of colored filters and exposure times, I photographed the shelter ceiling. The results were disappointing. The photographs did produce meager evidence that something was drawn on the ceiling, but the drawings remained illusive and undefined.

Abandoning the attempt for a time, I continued with other aspects of the Rock Art Survey. Months passed before I met Brian Johnson, an artist and photographer who suggested that we photograph the ceiling using his digital camera and then use a computer-graphics program to see if the images could be enhanced enough to be recognizable. To maintain a degree of consistent distance between the camera and shelter ceiling, we lay on the shelter floor and photographed the ceiling in sequential, overlapping, panels (plate 14b). After we loaded them onto a computer, the unaltered photographs initially revealed little evidence of the drawings (plate 15a), but Brian was able to use Photoshop software to tweak the drawings to a high degree of visibility (plate 15b). After he finished with all the individual photographs, he fitted them together to illustrate the pictograph in its entirety (plate 16a). The results were nothing less than incredible. Drawn with orange ocher, the pictograph consists of seven circles, a concentric circle, and abstract lines and motifs randomly placed across the domed ceiling.

Inspired by Brian's success with recreating the pictographs at site 38KE281, I purchased a digital camera and have studied to upgrade my own capabilities for working with computer graphics. The combination proved among our most useful tools for defining and recording rock art. Thereafter, as a matter of course when surveying, we photographed all potential rock-shelter walls. and then examined the photographs using Photoshop software. Unfortunately we have discovered no additional pictographs.

Conclusion

After nine years of periodic survey, a reasonable profile of South Carolina's rock-art sites has been established. Sixty-one petroglyph sites and three pictograph sites have been recorded. Although other rock-art sites will surely be discovered, it appears unlikely that the present pattern of distribution will be drastically altered. The majority of rock art believed to be prehistoric was discovered in the northwestern portion of the Piedmont and the adjacent Blue Ridge Mountains. Presently no explanation is forthcoming for the paucity of prehistoric rock art on the southern, eastern, and lower western Piedmont, where rock amenable to the practice is also abundant. Historic petroglyphs are more widely distributed across the Piedmont and mountains.

Because petroglyphs and pictographs are individually created, each is unique. Comparing the prehistoric rock art of South Carolina with that of Georgia and North Carolina has revealed few similarities. As a rule, the recorded petroglyphs of those two states are much more elaborate, more boldly carved, and more visible than most of the South Carolina petroglyphs discovered so far. It seems logical that rock art similar to that found in states immediately adjacent to South Carolina should also occur in this state, but other than the utilitarian circle-and-line petroglyphs and a few cupules, little has been found that is similar in form or motif to rock art of the region or the rest of the nation. The reason for this is unclear. It is possible that rock art in adjacent states is more recent and therefore reflects different cultural traditions. It is also possible that those states have rock art similar to ours that is yet to be discovered. Most of our lowland petroglyphs were found on dark rainy days or by examining rocks at night with lights. I am unaware that these survey methods have been tried in Georgia or North Carolina, and if they should be, perhaps motifs similar to those in South Carolina might be found.

Based on our observations in the field, we concluded that the prehistoric rock art of South Carolina is well on its way to extinction, threatened not only by forces of nature but also by economic and population growth and the subsequent expansion of facilities necessary to maintain it. If hard evidence is needed to support the urgency of recording the remaining South Carolina rock art, it has been demonstrated by the

known destruction of eight petroglyph sites in recent years—before they were documented.

Informed of a petroglyph located immediately beside a small stream in Pickens County, we contacted the landowner to ask permission to visit the site. He confirmed that a rock with "markings" had indeed existed on his property, but we were also told that the petroglyph had recently been destroyed as he altered the landscape to construct a pond.

Another person reported carvings on a large boulder beside a modest stream in Pickens County. He said there were several different carvings on the rock: a half circle, an arrowlike motif, and some abstract forms. Visiting the site, we found the boulder bottom side up in the stream, where it had been pushed by a bulldozer clearing land. It was now impossible to see whatever may have been carved on it. Locals had called the rock "the natural bridge" because it had protruded out over the creek. The informant, nearing eighty years of age, said his grandparents knew of these petroglyphs, but they had no idea who may have carved them.

A trek to another reported rock carving did result in the recording of a petroglyph, site 38SP337 in Spartanburg County. Immediately adjacent to this glyph, the landscape had been altered by land clearing, and my host said that close by within the cleared tract there had been another petroglyph. The rocks were badly damaged by bulldozers and efforts to locate any remaining portions of the glyph were futile. The petroglyph we did record was later removed during additional clearing for house construction. Its current status is unknown.

We received a request to visit Spartanburg County and inspect several petroglyphs known to a local family. While the first site was still intact, we found that we had recorded it earlier when it was reported by another person (38SP336). At the second potential site, however, we found that a new housing development was now spread over the area and that a dam had been constructed to create a community pond. The rock carving was said to be near where the dam was constructed, and it is now beneath the lake or the dam. Proceeding to a third site, we again met with disaster as this site had also been destroyed. Located in one of the most beautiful spots in upstate South Carolina and adjacent to a large cascade in the Enoree River, are a series of very large and relatively flat boulders—one or more petroglyphs are said to have been located on one of these. The site had only recently been destroyed by construction of a sewer line that cut through the rock formation and in the process destroyed the rock carving.

A call from Georgia informed us of a large rock in Oconee County, South Carolina, near the town of West Union, with "Indian writing" on it. The informant, previously a resident of West Union, lived some distance away and had not seen the site in many years. Given directions, we visited the site only to learn that recent construction of a large supermarket and strip mall had completely removed the rock. We were unable to learn what might have happened to it, but given its reported size, it was likely blasted apart for removal.

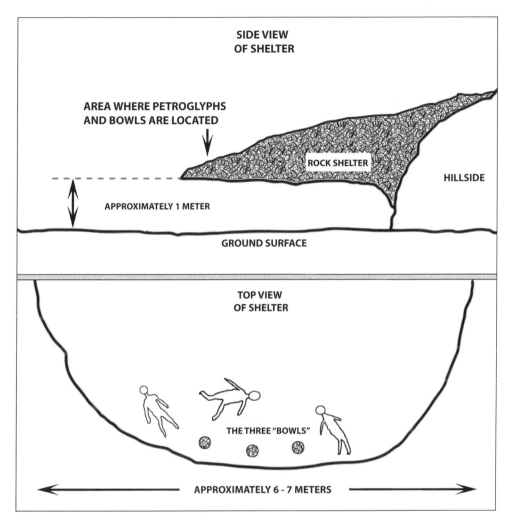

Fig. 101. A rock shelter and petroglyphs destroyed by rock quarrying.
Based on a drawing by Clyde H. Rook

Even before we formally began the rock-art survey, we investigated reports of rock carvings only to discover that they had already met their demise. In 1989 a landowner in Lexington County found what appeared to be one or more petroglyphs on a large, flat boulder. She called SCIAA to ask if we might be interested in seeing her find, but in the meantime she contracted a timber company to clear her land so she might convert it to pasture. When I visited the landowner a few days later, she took me to the rock outcrop on her property only to find that a bulldozer had crawled all over the rock, completely destroying whatever petroglyphs may have been there.

Perhaps the greatest disappointment, originated with a letter received in 1987. The writer, Clyde H. Rook, stated that he was sixty years of age and that many years prior he "wrote to the University of South Carolina expressing my concern that an exceptionally interesting historical fact may be lost to us and the future if someone

doesn't 'grab hold' of this thing and explore it." There was no response to the informant's first letter, so he sent his second letter in 1987, again appealing for someone to investigate this site in Spartanburg County while warning that it might already be too late because a large stone quarry had begun operation nearby. The writer gave some details of his childhood, when he and friends played around and under a rock shelter they called their "secret place." He remembered that there were three "bowl-like" carvings on the top and near the edge of the shelter and three humanlike figures. He sent a drawing to illustrate the site as he remembered it (fig. 101). The writer no longer lived in the area, but he gave us the name of the person most likely to be able to help us find it: Major William Millwood. When we located Millwood, who still lives near the site, he told us that the rock shelter had been destroyed by the quarry operations.

If news of this much site destruction was gleaned from so few people, many other sites must have been destroyed without our ever becoming aware of their existence. How many more will be lost without our knowing of them? However, the major cause for concern may be something much more subtle, widespread, and destructive—the pollution of our air and the resulting acid rains that may be accelerating erosive processes. It is well known that in recent decades acid rains have done considerable damage to gravestones, marble statuary, and building facades over much of the world, and there is little reason to doubt that it has had a similar effect on rock art.

The South Carolina Rock Art Survey strongly believes that our state's remaining petroglyphs, particularly those located on lowland sites, are in a very precarious condition; some glyphs are on rocks whose surfaces are so fragile that exfoliating rock can be removed and crushed by a person's fingers. Because of the accelerating causes of their destruction, preservation for the majority of our states rock art seems a moot point. Our observations in the field indicate that most of our lowland rock art is already in a near-terminal state, and it is reasonable to believe that much, or perhaps most, of the undiscovered examples are already eroded beyond our ability to find them. It is not a question of will our state's rock art become extinct, but rather how long the process will take. The endeavor to record these rare facets of our nations heritage should be carried forward with some urgency.

Our survey explored only properties whose owners gave us permission, rocks that were relatively easy to get to—those near roads and trails or within a one-day hike. Given the impressive results of our survey over a relatively minuscule area, it is obvious that there must be large numbers of other sites waiting to be discovered. There are hundreds of thousands of acres of private and public land still not explored. Every hillside, valley, creek bank, and rock shelter—wherever rock is found—is a potential site for rock art. The lowland sites that we found are in such easily accessible places that the idea that they are unique or rare is ludicrous.

The answer to searching the remaining vast area for additional rock art lies in public awareness and involvement. A few researchers, no matter how dedicated, will

never be able to examine all the landforms under the proper conditions to find all the rock art that might exist, but if the public becomes involved, there is no reason that the South Carolina rock-art count cannot be dramatically increased. Keep in mind that the South Carolina Rock Art Survey was conducted only periodically over a period of nine years. Our eventual success far exceeded our expectations and indicates that the best could still lie ahead. We hope that searching for rock art will become a routine part of all archaeological surveys conducted in the upstate. We have demonstrated that rock art exists in South Carolina and that finding and properly recording it is not easy, but the thrill of each new discovery is rewarding beyond anything I have experienced in the discipline of archaeology.

References

Allen, Mary. 2004. The Utah Rock Art Research Association. *Vestiges* 24, no. 1: 15.

Baker, Stanley W. 1978. A preliminary survey of petroglyph sites in Meigs County, Ohio. *Ohio Archaeologist* 28, no. 2: 22–26.

Beck, Bruce. 1982. A summery opinion of the excavation of Muhlenberg site no. 1. Manuscript on file at the Owenboro Area Museum, Owenboro, and the Kentucky Heritage Council, Frankfort.

Birmingham, Robert A., and Leslie E. Eisenberg. 2000. *Indian mounds of Wisconsin.* Madison: University of Wisconsin Press.

Blount, Robert S., III. 1992. Spirits in the pines. M.A. thesis. Florida State University.

Bright, Pascal A. 1932. The making of pine tar in Hocking County. Ohio. *Ohio Archaeological and Historical Quarterly* 41, no. 2:151–60.

Brown, James. 2004. The Cahokian expression: Creating court and cult. In *Hero, hawk, and open hand: American Indian art of the ancient Midwest and South,* ed. Richard F. Townsend and Robert V. Sharp, 105–23. Chicago & New Haven: Art Institute of Chicago / Yale University Press.

———. 2007. On the identity of the birdman within Mississippian period art and iconography. In *Ancient objects and sacred realms: Interpretations of Mississippian iconography,* ed. F. Kent Reilly III and James F. Garber, 56–106. Austin: University of Texas Press.

Butler, Carroll B. *Treasures of the longleaf pines: Naval stores.* Rev. ed. Shalimar, Fla.: Tarkel Publishing, 1998.

Carlton, Craig, and Dale Ferguson. 1977. Making tar. In *Foxfire 4,* ed. Eliot Wiggington, 252–56. Garden City, N.Y.: Anchor/Doubleday.

Charles, Tommy. 1997. The South Carolina Rock Art Survey. ESRARA Research Report no. 3. *Newsletter of the Eastern States Rock Art Research Association* 2, no. 2:2–4.

Coy, Fred E., Jr., Thomas C. Fuller, Larry G. Meadows, and James L. Swauger. 1997. *Rock art of Kentucky.* Lexington: University Press of Kentucky.

Cyrus, Thomas. 1891. *Catalogue of prehistoric works east of the Rocky Mountains.* Bureau of American Ethnology Bulletin no. 12. Washington, D.C.: U.S. Government Printing Office.

Diaz-Granados, Carol, and James R. Duncan. 2000. *The petroglyphs and pictographs of Missouri.* Tuscaloosa & London: University of Alabama Press.

———, eds. 2004. *The rock-art of eastern North America. Capturing images and insight.* Tuscaloosa: University of Alabama Press.

Earle, Alice Morse. 1898. *Home life in colonial days.* New York: Macmillan.

Ford, Robert, Dixon Spendlove, Cody Spendlove, David Maxwell, and Gordon Hutchings. 2004. Waterglyphs: Ancient cartography of the Arizona strip. In *Papers presented at the twenty-fourth annual symposium of the Utah Rock Art Research Association, Kanab, Utah,*

October 2004, ed. Carol B. Patterson, 29. Utah Rock Art, vol. 24. Utah Rock Art Research Association (URARA).

Gamble, Thomas, ed. 1921. *Naval stores: history, production, distribution and consumption.* Savannah: Review Publishing & Printing.

Gould, Mary Earle. 1948. *Early American wooden ware and other kitchen utensils.* Rev. ed. Springfield, Mass.: Pond-Ekberg.

Hall, James A. 1933. Untitled article on tar extraction. In *History of Hart County* [Georgia], by John William Baker. N.p.

Heizer, Robert F., and Martin A. Baumhoff. 1962. *Prehistoric rock art of Nevada and eastern California.* Berkeley: University of California Press.

Henson, Bart, and John Martz. 1979. *Alabama's aboriginal rock art.* Montgomery: Alabama Historical Commission.

Hobson, Ian. 2006. British Rock Art Collection (BRAC). Castricum, Netherlands.

Hockensmith, Charles D. 1986. Euro-American petroglyphs associated with pine tar kilns and lye leaching devices in Kentucky. *Tennessee Anthropologist* 11 (Fall): 100–31.

———. 1994. Experimental pine tar manufacture at Cumberland Falls State Park, Kentucky. *Tennessee Anthropologist* 19 (Spring): 28–45.

———. 1996. Circle and line petroglyphs: Historic carvings mistaken for prehistoric petroglyphs. In *Rock art of the eastern woodlands,* ed. Charles H. Faulkner, 99–110. Proceedings of the Eastern States Rock Art Conference, Natural Bridge State Park, Kentucky, April 10, 1993. American Rock Art Research Association Occasional Paper 2.

Hockensmith, Charles D., and Cecil R. Ison. 1996. Kentucky's historic pine tar industry: Comparisons between large and small scale production technologies. *West Virginia Archaeologist* 48 (Spring/Fall): 1–18.

Horton, J. Wright, Jr., and Connie L. Dicken. 2001. Preliminary digital geologic map of the Appalachian Piedmont and Blue Ridge, South Carolina segment. U.S. Geological Survey Open-File Report 01-298, U.S. Geological Survey, Reston, Virginia.

Ison, Cecil R., and Charles D. Hockensmith. 1995. Pine tar manufacture in eastern Kentucky: A forgotten forest industry. In *Historical archaeology in Kentucky,* ed. Kim A. McBride, W. Stephen McBride, and David Pollack, 21–50. Frankfort: Kentucky Heritage Council.

Jones, Lewis P. 1978. *South Carolina: A synoptic history for laymen.* Rev. ed. Lexington, S.C.: Sandlapper.

Kolber, Jane. 1998. *Arizona Archaeological Society Rock Art Recording Field School rock art recording guide.* N.p.: Privately printed.

Lady, Lynn C., and Robert F. Maslowski. 1981. Historic rock carvings in the Ohio Valley. *West Virginia History* 42, no. 1–2:83–93.

Lenik, Edward J. 2002. *Picture rocks: American Indian rock art in the northeast woodlands.* Hanover & London: University Press of New England.

Little, Willie. 1975. Oral history concerning pine-tar production on Tarr Ridge, Menifee County, Kentucky. Interview taped by Fred E. Coy Jr. On file at Heritage Program, U.S. Forest Service, Winchester, Ky.

Mallery, Garrick. 1972. *Picture-writing of the American Indians.* 2 vols. New York: Dover.

Mohr, Merilyn. 1979. *The art of soapmaking.* Camden East, Ont.: Camden House.

Murphy, James L. 1969. A note on tar burner rocks. *Ohio Archaeologist* 19, no. 4: 115–17.

Nevin, Paul. 2004. Rock-art sites on the Susquehanna River. In *The rock-art of eastern North America,* ed. Carol Diaz-Granados and James R. Duncan, 239–57. Tuscaloosa: University of Alabama Press.

Perryman, Margaret (Francis Smith). 1964. Georgia petroglyphs. *Archaeology* 17, no. 1:54–56.

South Carolina naturally. 2001. Online at sciway2.net/2001/sc-geology (accessed October 28, 2009).

Stephenson, Robert L. 1979. Untitled report on petroglyph at site 38GR9. Greenville County. South Carolina Statewide Archaeological Site Inventory Offices, South Carolina Institute of Archaeology and Anthropology, University of South Carolina, Columbia.

Steward, Julian H. 1937. Petroglyphs of the United States. In Bureau of American Ethnology, *Smithsonian report for 1936*, 405–25. Washington, D.C.: U.S. Government Printing Office, 1937.

Strong, John A. 1989. The Mississippian bird-man theme in cross-cultural perspective. In *The southeastern ceremonial complex: Artifacts and analysis,* ed. Patricia Galloway, 211–38. Lincoln: University of Nebraska Press.

Swauger, James L. 1981. Petroglyphs, tar burner rocks, and lye leaching stones. *Pennsylvania Archaeologist* 51 (April): 1–7.

———. 1984. *Petroglyphs of Ohio.* Athens: Ohio University Press.

U.S. Geological Survey, U.S. Department of the Interior. 2000. The fall line: A tapestry of time and terrain, online at http://tapestry.usgs.gov/features/14fallline.html (accessed October 28, 2009).

Wallace, D. D. 1936. Pardo's route through South Carolina in 1567. *Hispanic American Historical Review* 16 (August):447–50.

Weinland, Marcia K., and Gerald N. DeLorenze. 1980. A reconnaissance and evaluation of archaeological sites in Hopkins County, Kentucky. Kentucky Heritage Commission, Archaeological Survey Reports, no. 15.

White, Vernon. 1980. Unanswered questions from historic or prehistoric Kentucky. *Kentucky Archaeological Association Bulletin* 14/15:55–63.

Wiltse, Leah Showers. 1999. *Pioneer Days in the Catskill High Peaks,* ed. Shirley W. Dunn. Hensonville, N.Y.: Black Dome Press.

Index